SABAN'S POWER RANGERS

ARTIST TRIBUTE

BOOM! STUDIOS

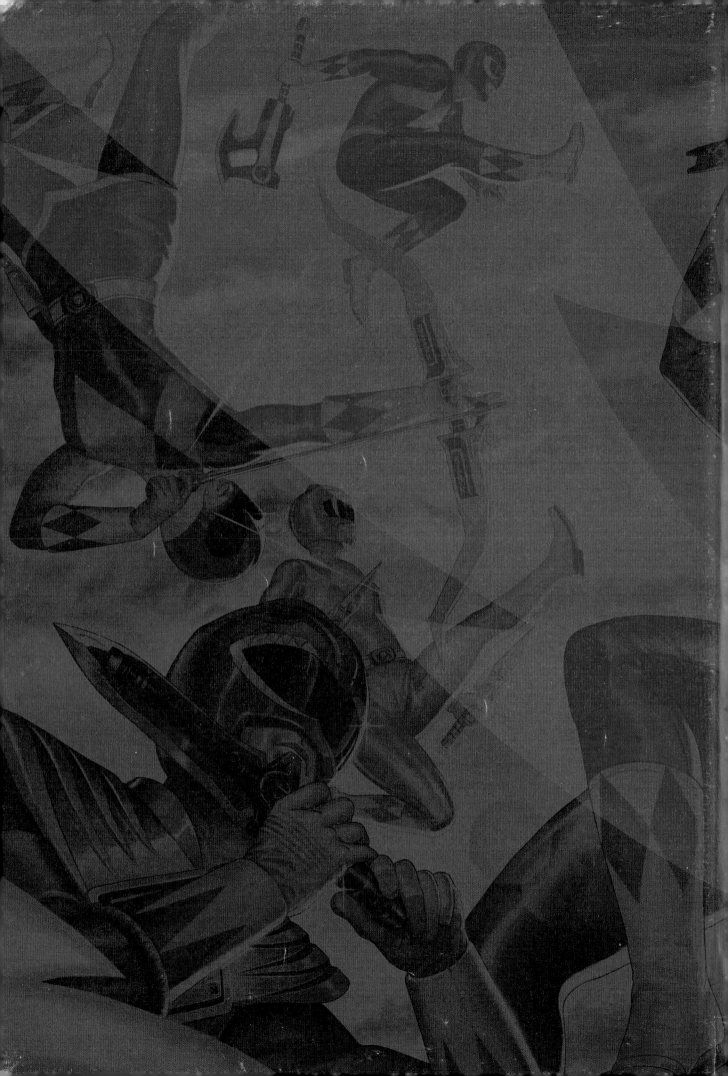

SABAN'S POWER RANGERS

ARTIST TRIBUTE

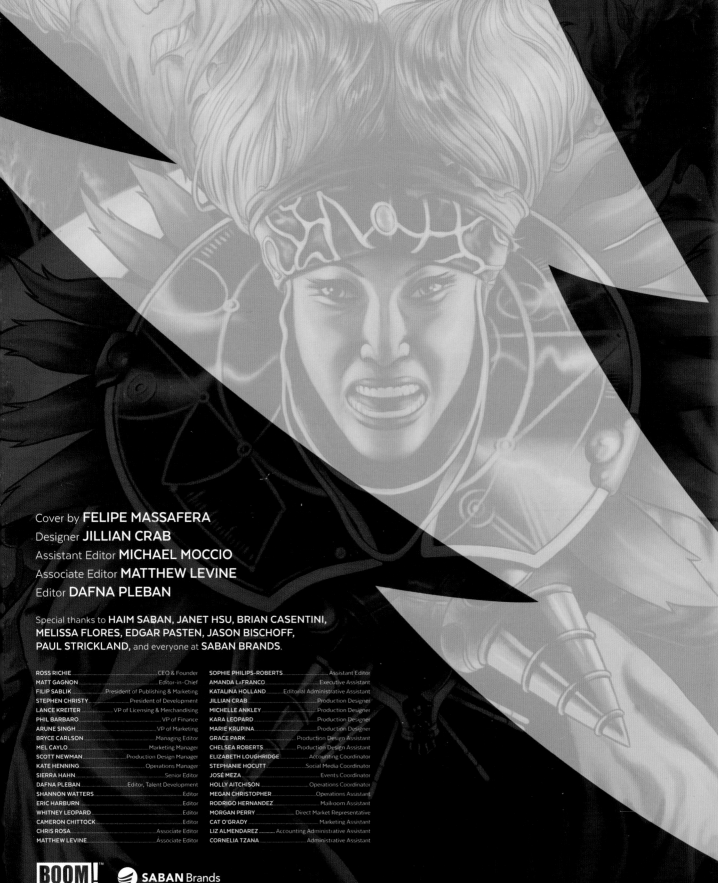

Cover by **FELIPE MASSAFERA**
Designer **JILLIAN CRAB**
Assistant Editor **MICHAEL MOCCIO**
Associate Editor **MATTHEW LEVINE**
Editor **DAFNA PLEBAN**

Special thanks to **HAIM SABAN, JANET HSU, BRIAN CASENTINI,
MELISSA FLORES, EDGAR PASTEN, JASON BISCHOFF,
PAUL STRICKLAND,** and everyone at **SABAN BRANDS.**

ROSS RICHIE...............CEO & Founder	SOPHIE PHILIPS-ROBERTS.............Assistant Editor
MATT GAGNON...............Editor-in-Chief	AMANDA LaFRANCO.............Executive Assistant
FILIP SABLIK...............President of Publishing & Marketing	KATALINA HOLLAND.........Editorial Administrative Assistant
STEPHEN CHRISTY...............President of Development	JILLIAN CRAB.............Production Designer
LANCE KREITER...............VP of Licensing & Merchandising	MICHELLE ANKLEY.............Production Designer
PHIL BARBARO...............VP of Finance	KARA LEOPARD.............Production Designer
ARUNE SINGH...............VP of Marketing	MARIE KRUPINA.............Production Designer
BRYCE CARLSON...............Managing Editor	GRACE PARK.............Production Design Assistant
MEL CAYLO...............Marketing Manager	CHELSEA ROBERTS.............Production Design Assistant
SCOTT NEWMAN...............Production Design Manager	ELIZABETH LOUGHRIDGE.............Accounting Coordinator
KATE HENNING...............Operations Manager	STEPHANIE HOCUTT.............Social Media Coordinator
SIERRA HAHN...............Senior Editor	JOSÉ MEZA.............Events Coordinator
DAFNA PLEBAN...............Editor, Talent Development	HOLLY AITCHISON.............Operations Coordinator
SHANNON WATTERS...............Editor	MEGAN CHRISTOPHER.............Operations Assistant
ERIC HARBURN...............Editor	RODRIGO HERNANDEZ.............Mailroom Assistant
WHITNEY LEOPARD...............Editor	MORGAN PERRY.............Direct Market Representative
CAMERON CHITTOCK...............Editor	CAT O'GRADY.............Marketing Assistant
CHRIS ROSA...............Associate Editor	LIZ ALMENDAREZ.............Accounting Administrative Assistant
MATTHEW LEVINE...............Associate Editor	CORNELIA TZANA.............Administrative Assistant

 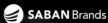

TABLE OF CONTENTS

FOREWORD

Bulk and Skull are idiots. Fortunately, Jason Narvy and I are coincidentally also idiots. This fortuitous conjunction of art and life gave us the most amazing opportunity as performers. Face it, when you play a dolt on TV, the bar is set pretty low in terms of what viewers expect of you when they happen to meet you in person. Demonstrating even basic life skills like pumping gas or buying a loaf of bread gives people we meet the humorous revelation that we're dumb, but maybe not as dumb as on TV.

I said *maybe*.

The role of Farkas "Bulk" Bulkmeier was kindly written for me by some really good writers who understood the power of a classic comedic duo, especially in the context of a superhero action show. Giant robots and martial arts inspired moves are pretty awesome, but you need a counterpoint. We were lucky to have found ourselves playing exactly that role in *Mighty Morphin Power Rangers*. Usually, that counterpoint involved me getting hit in the face by a cake.

As we all know, Bulk & Skull grew and changed over the course of the many seasons and episodes we did together: Punks, Jr. Police, Monkeys, Private Detectives, Alien Hunters. We were able to evolve our characters from simple antagonistic supporting characters into well-developed and nuanced staples of the series.

I personally know many of you hated Bulk & Skull when you were younger because we were taking valuable screen time away from giant Zords and explosive fights. This is a totally understandable opinion coming from seven-year-old you. Well, I'm fairly certain you have come a full 180 on that opinion as a grownup and now can't imagine classic *Power Rangers* without us. I know you've been binging the original series online, and let's face it—Bulk & Skull coming onscreen is the perfect opportunity to hit the restroom or get some pizza. But you won't. You won't because Bulk & Skull are awesome.

Narvy and I have been enthralled by the BOOM! Studios portrayal of our now iconic characters! Seeing these numbskulls once again walking the halls of Angel Grove High gives us a smile. Seeing them finally don Ranger costumes and fulfill their destiny as real heroes isn't new ground completely (case in point, "Countdown to Destruction"), but this time it isn't a dream sequence. We're Morphin, y'all. That kind of thoughtful reinterpretation of the characters is inspiring.

When we do a new production of an old Shakespeare play, we are impelled to put our

own spin on things: We're driven to make our own statement on well-tread material. Now, 25 years into the amazing *Power Rangers* universe, something profound has changed. Something important.

You. You have changed.

You went and grew up, folding into your own experience the themes of friendship, teamwork, of doing the right thing the first time and reaching out your hand to help others in their time of need. I know there was a period in your life after you thought you outgrew *Power Rangers* where that familiar tune started to creep back into your subconscious. That killer guitar lick is infectious, inspiring millions of viewers. Some of those viewers turn out to be amazing artists who themselves feel the urge to interpret the *Power Rangers* universe in their own style. That spirit suffuses the book you now hold in your hands.

On the following pages, you'll find inspired takes on familiar and well-loved characters. This *Power Rangers Artist Tribute* is a testament to the power of nostalgia, and further proves that when you really love something, you don't need to explain why. In fact sometimes you can't. But—you have been summoned to make it your own, just like the skilled artists whose work is here presented.

What is it about *Power Rangers* that keeps this franchise alive and kicking? Well, we can each see ourselves somehow in these characters. There's a hero in every one of us, and it's always amazing to hear people articulate that over and over.

That's why I enjoyed both performing in and directing episodes of the series for so many years. When Narvy and I discuss our characters and the show, we're quite happy with the work onscreen. Being the counterpoint to the heroes suits us just fine, because as the skinny guy once profoundly said, "Heroes come and go, but idiots are forever".

Thanks for watching, and reading, for all these years.

Paul Schrier
Actor, Farkas "Bulk" Bulkmeier
October 2017

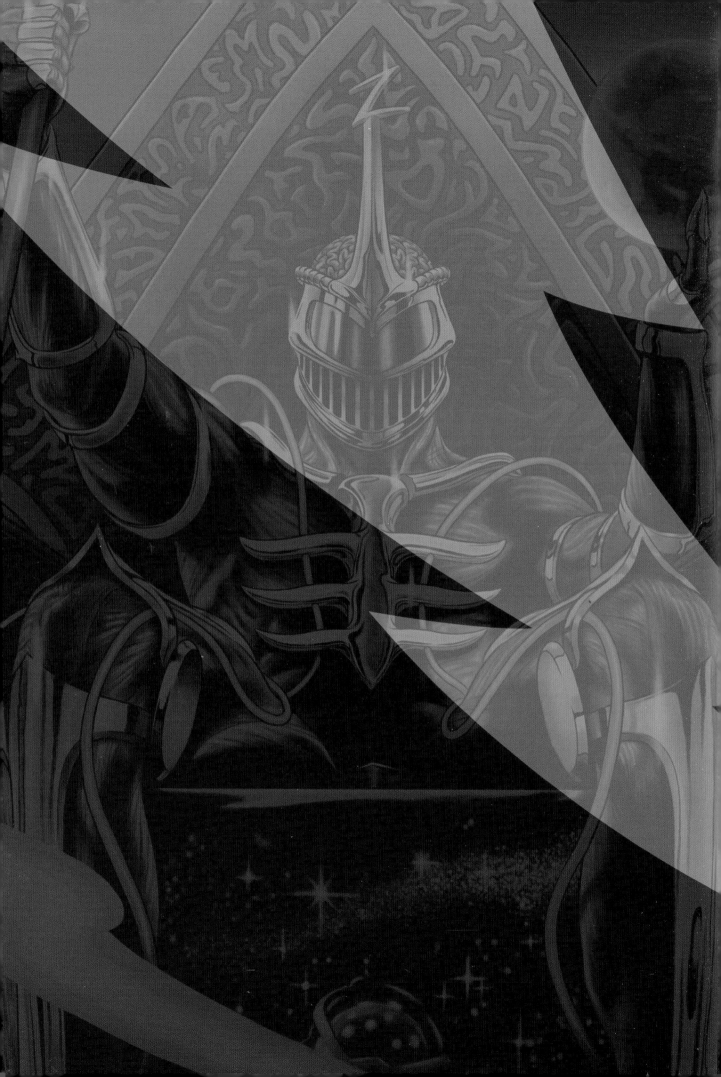

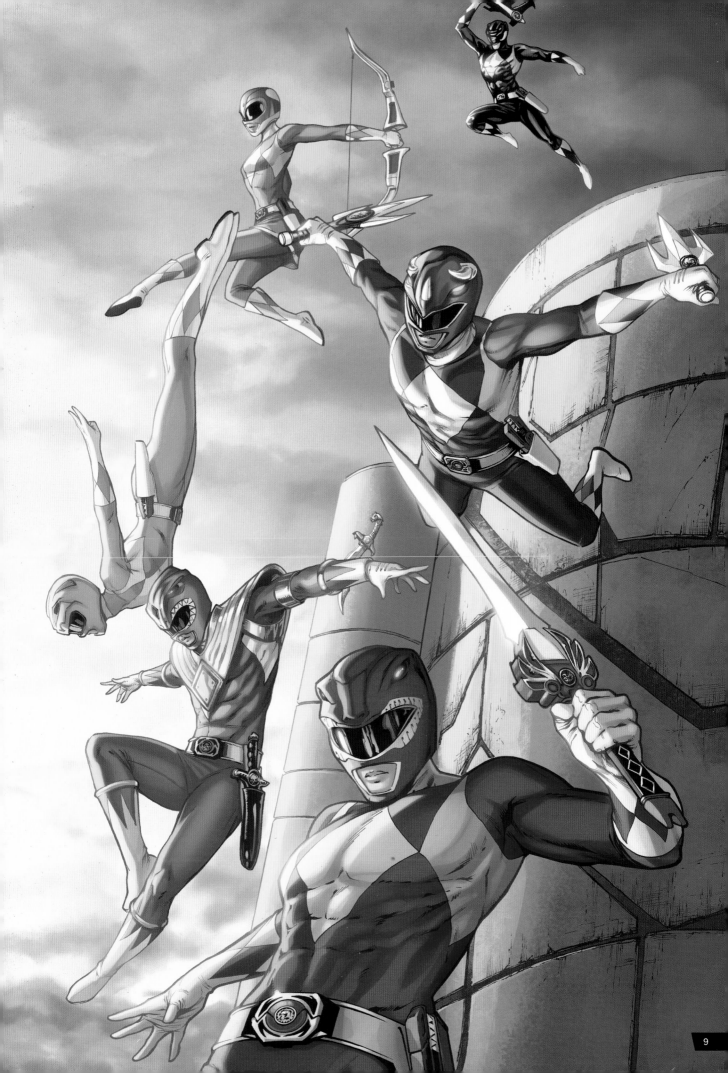

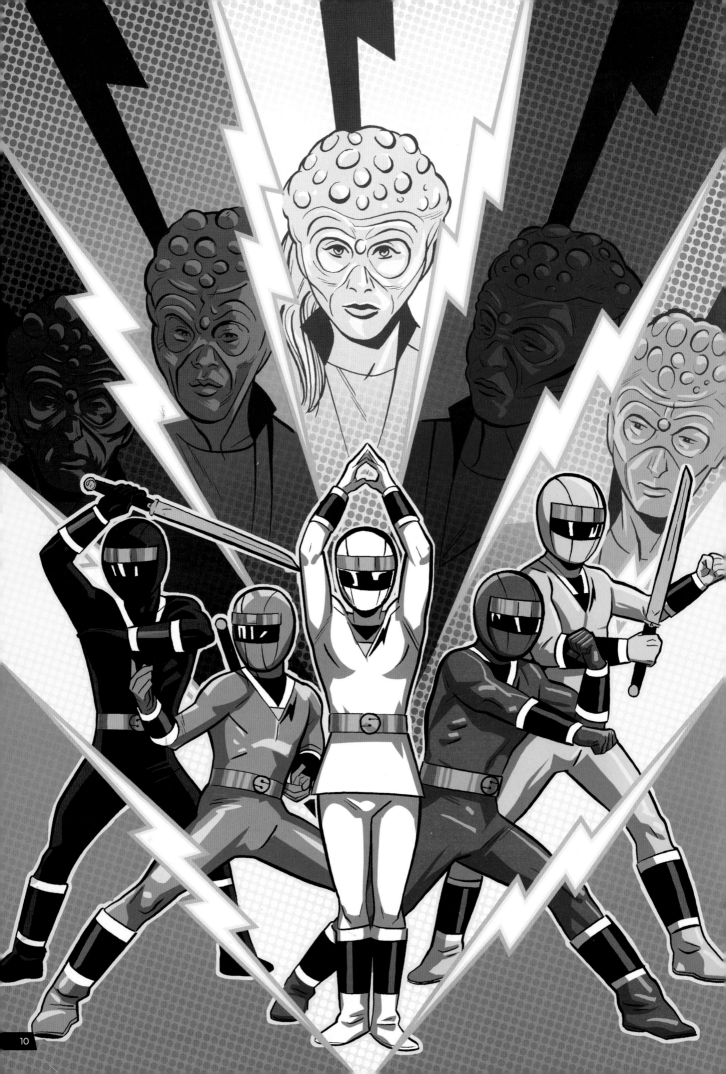

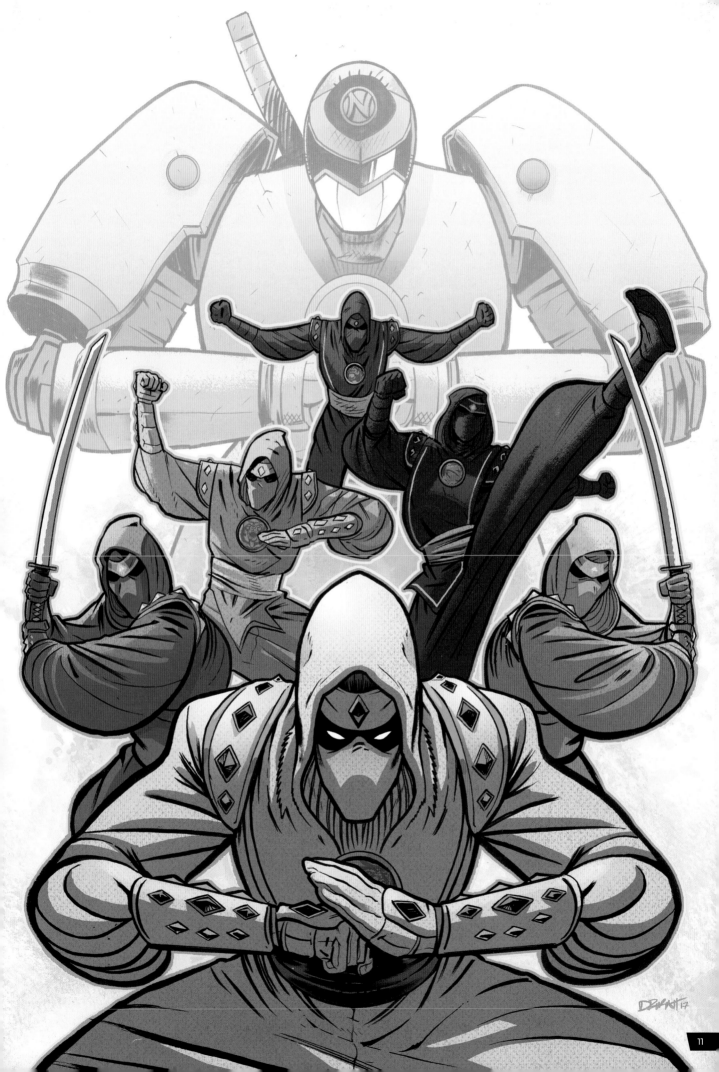

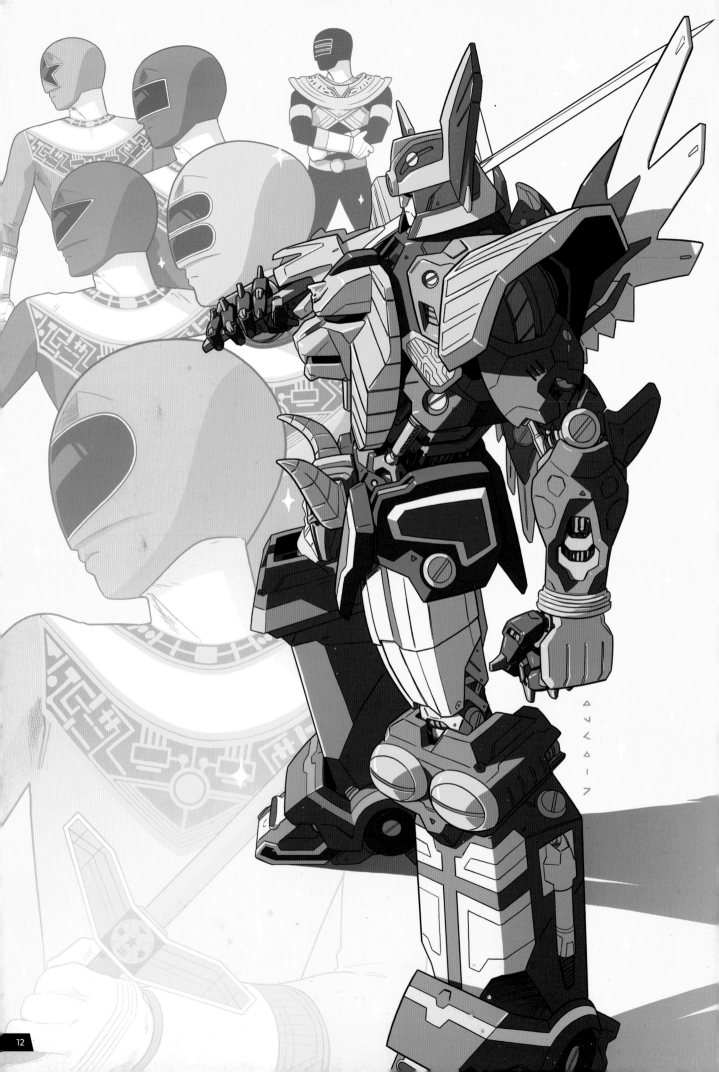

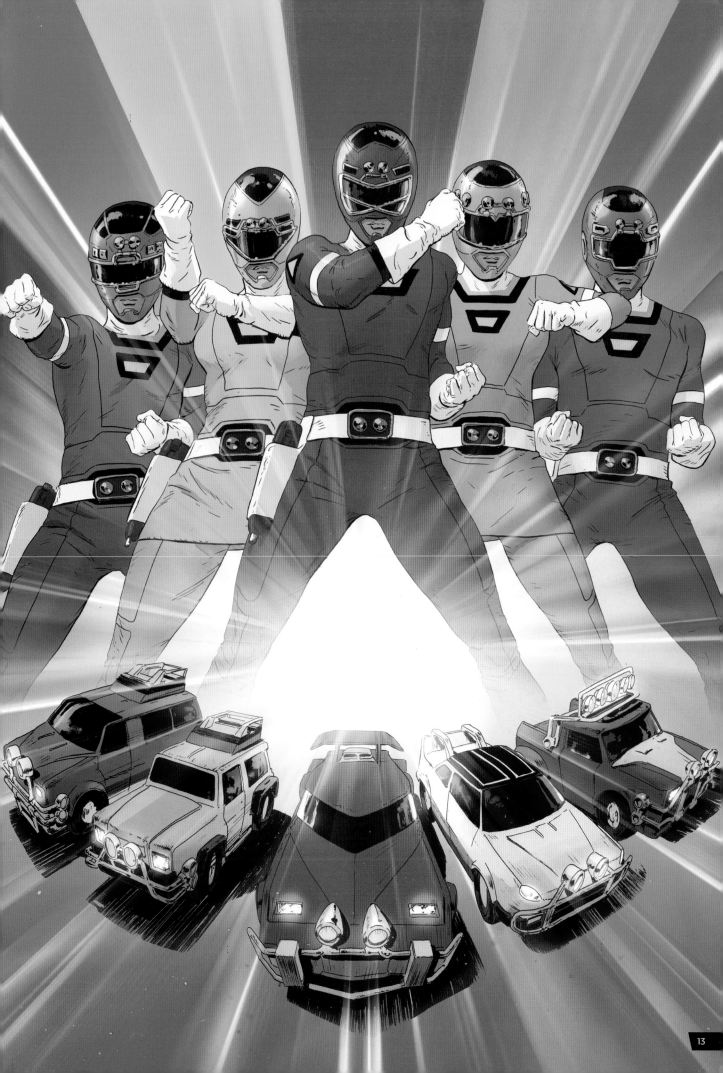

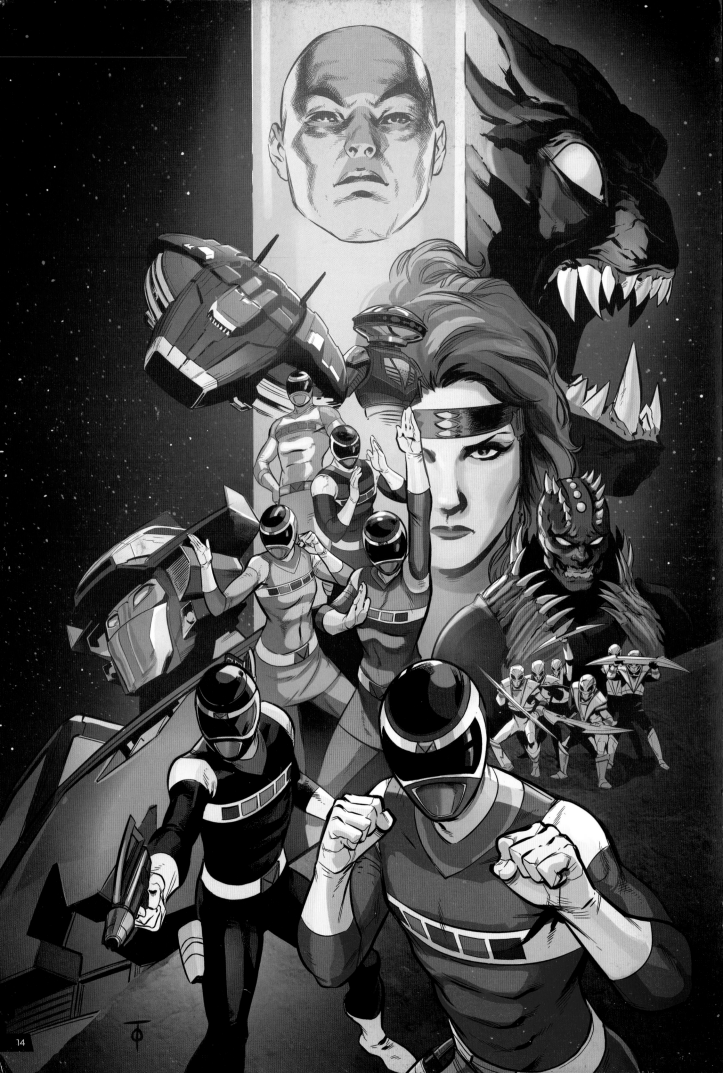

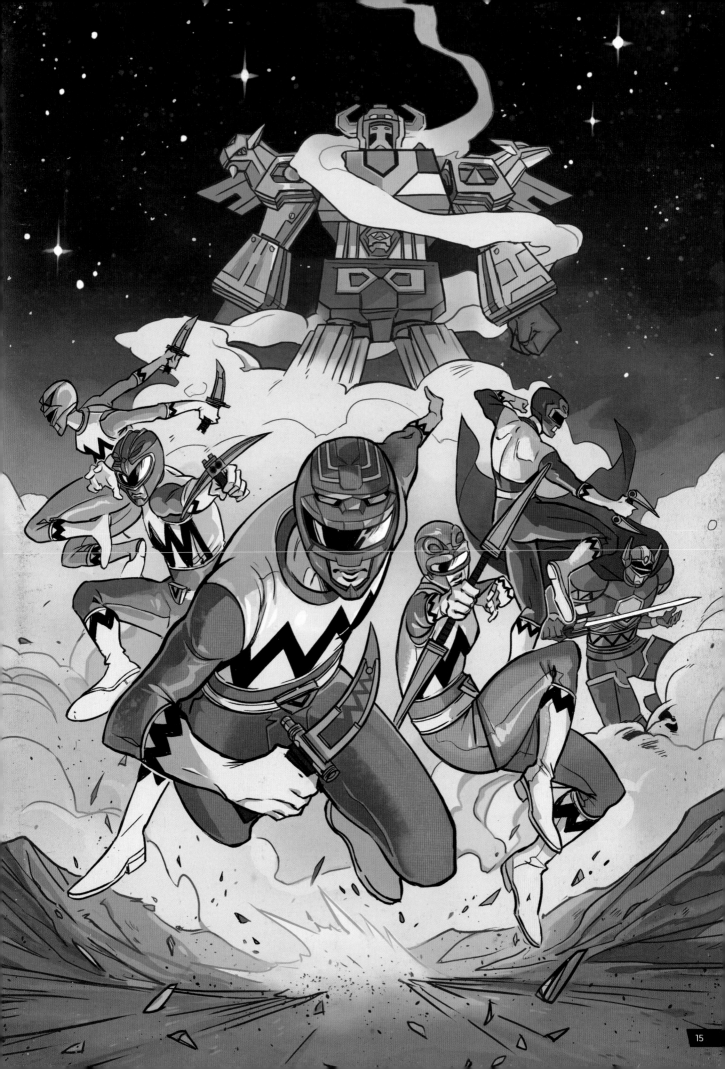

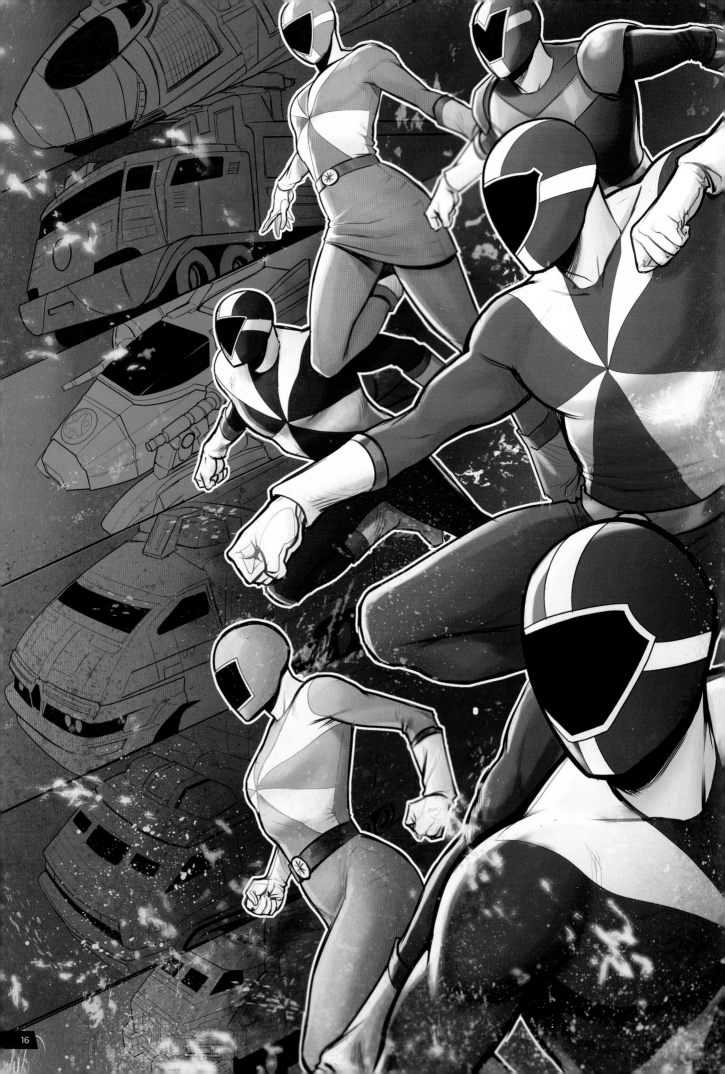

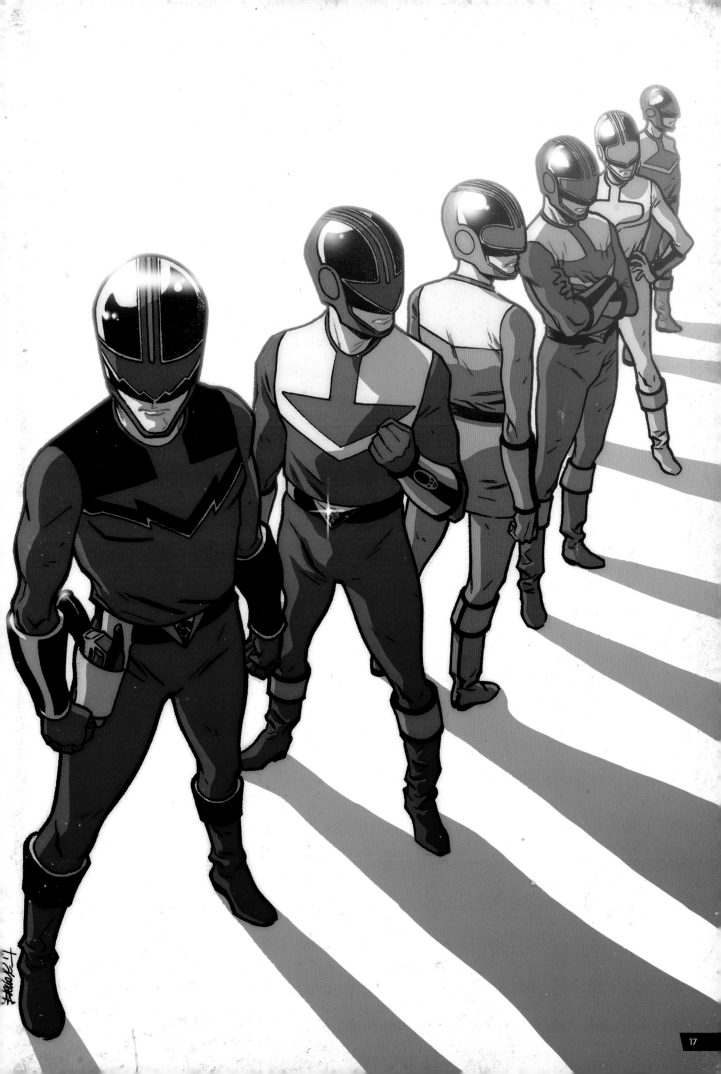

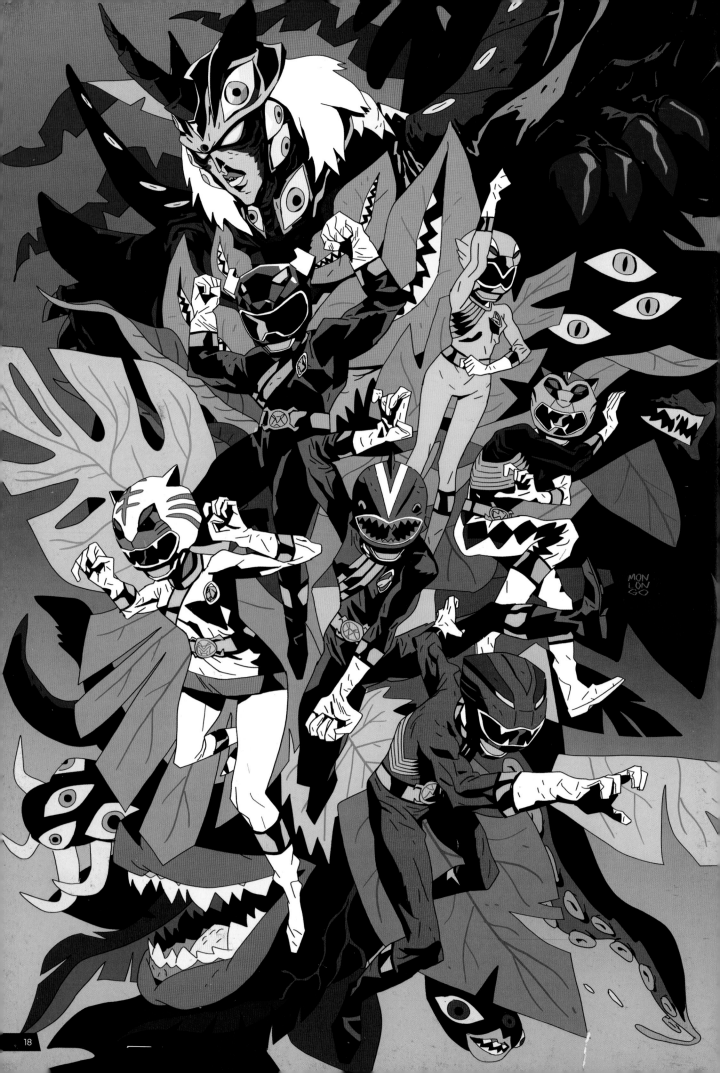

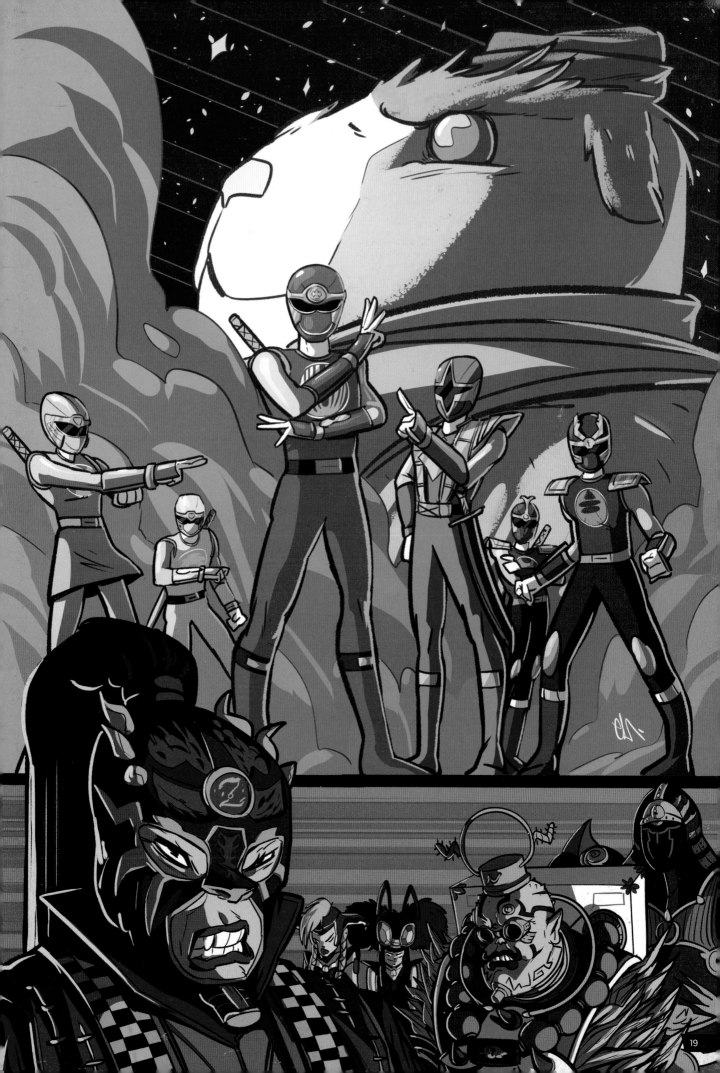

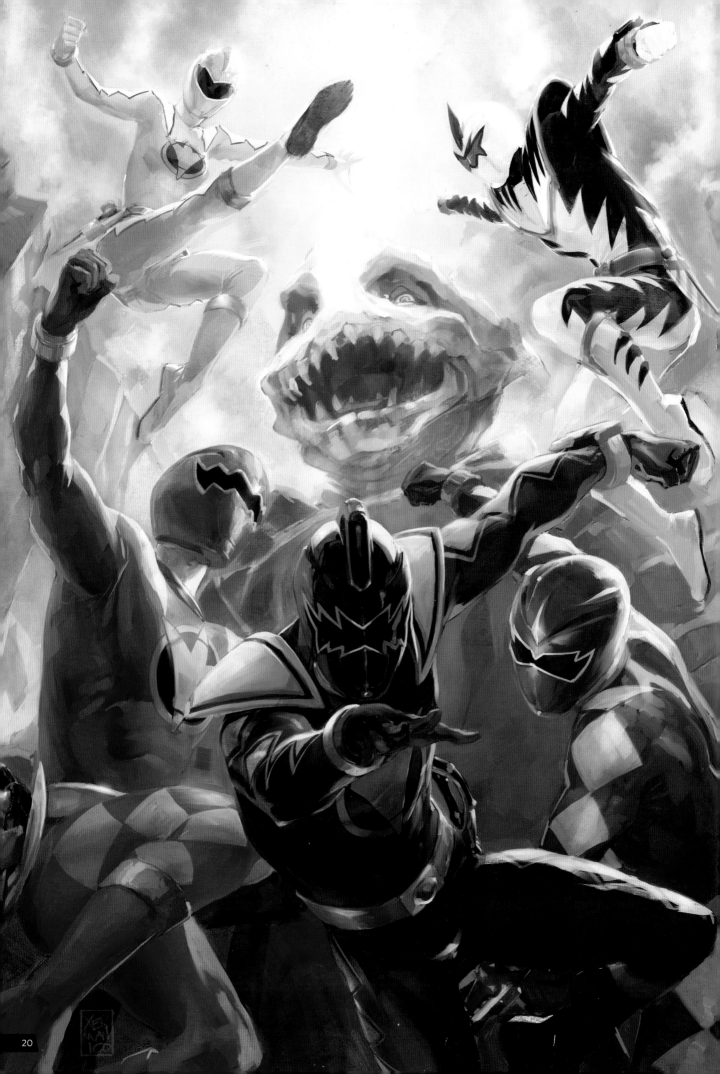

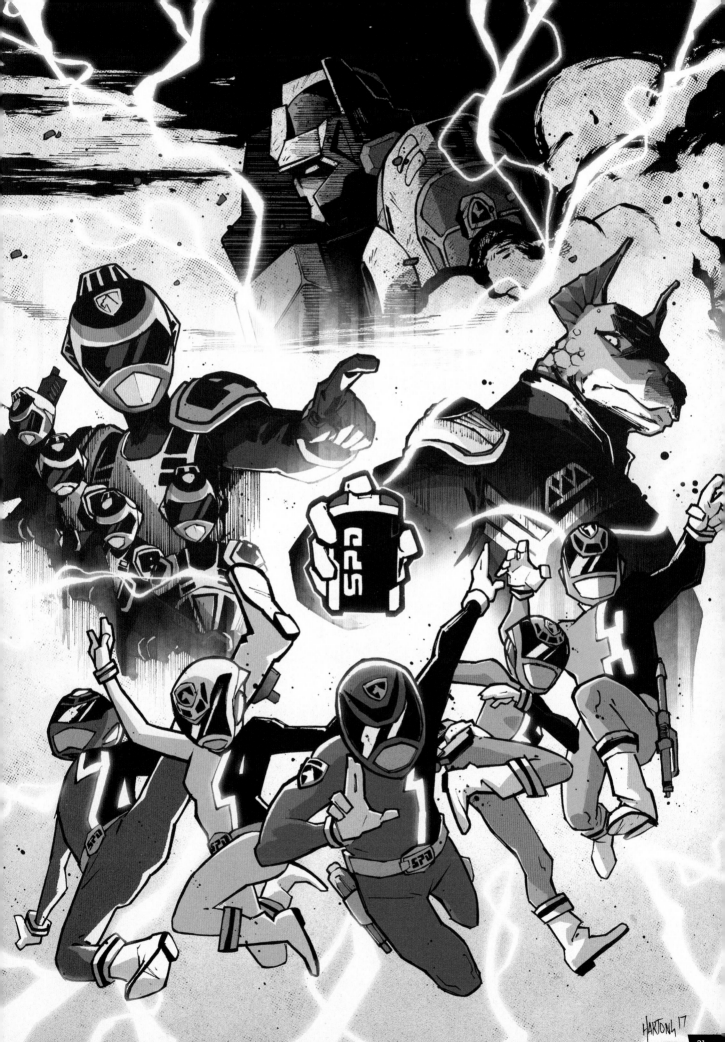

HARTONG 17

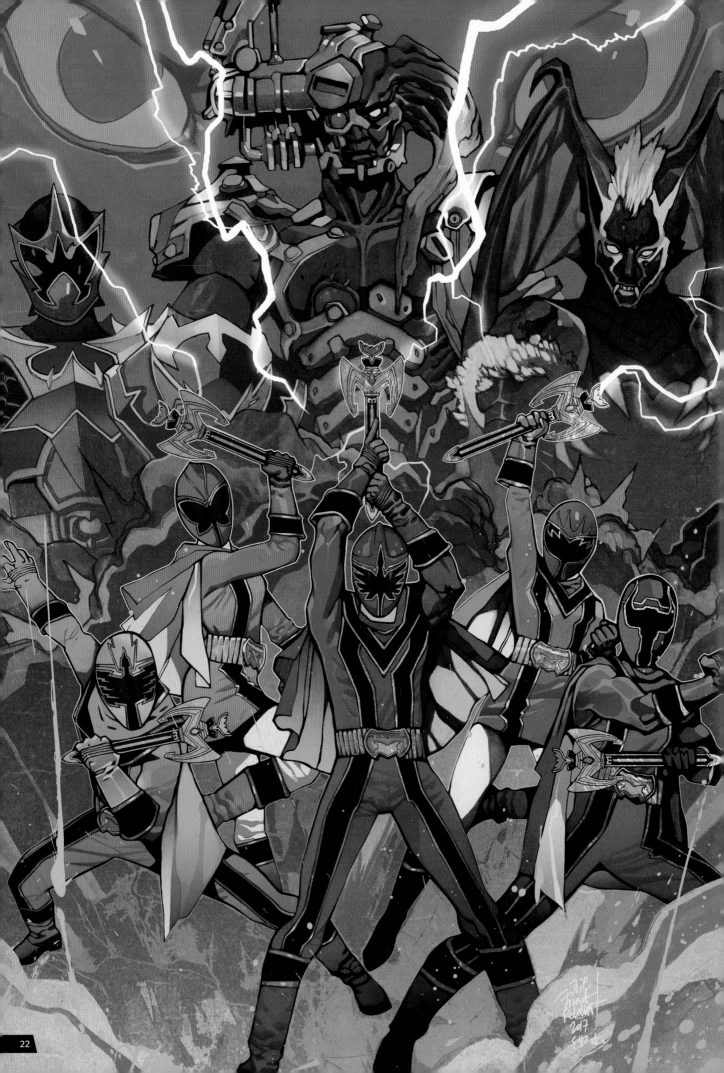

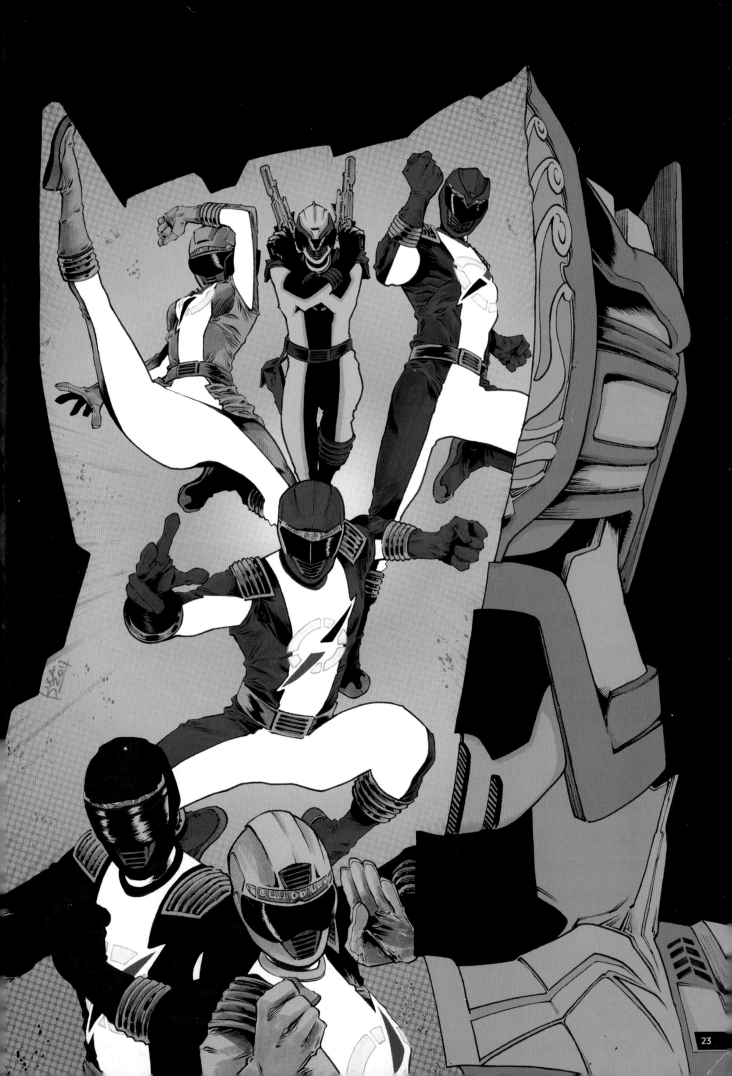

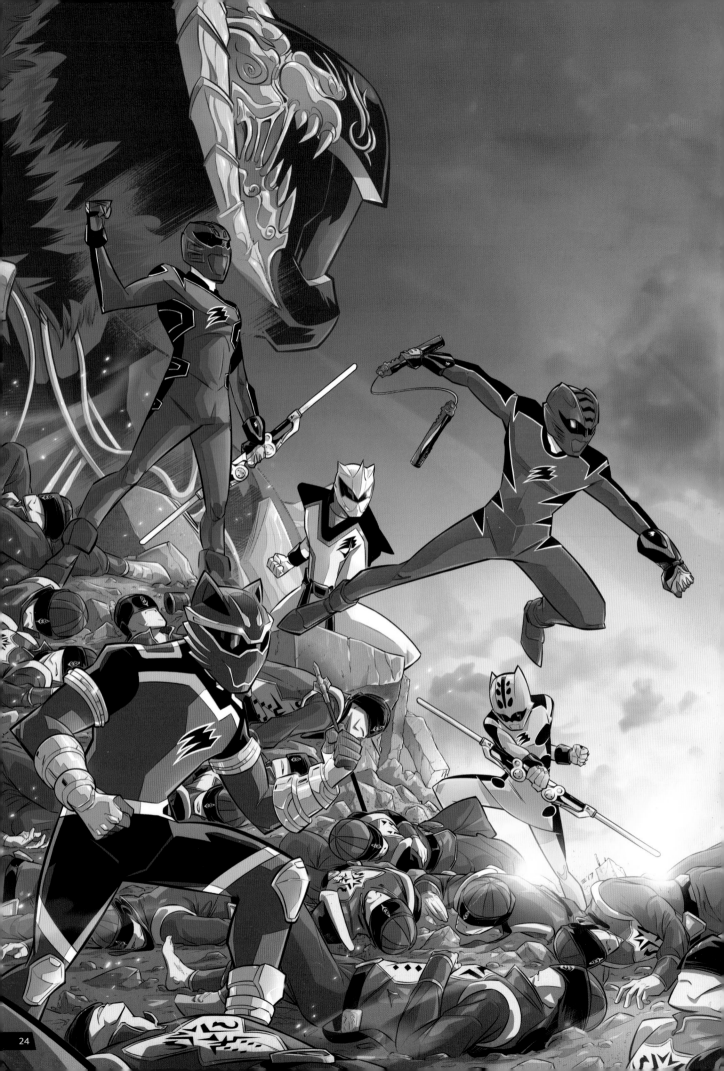

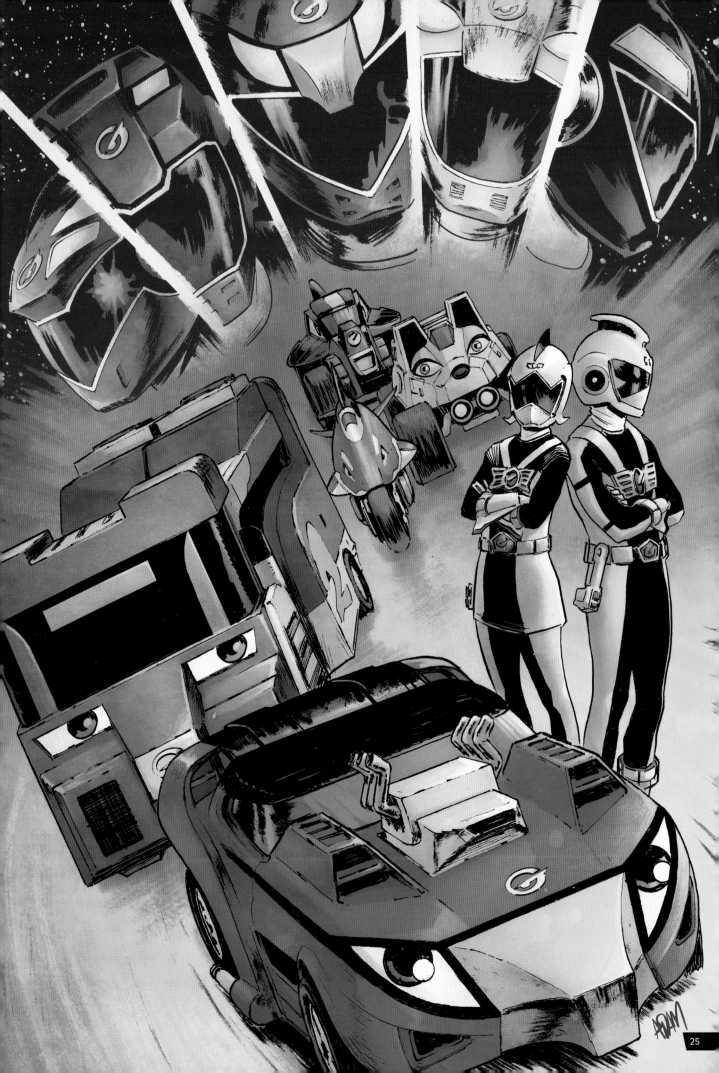

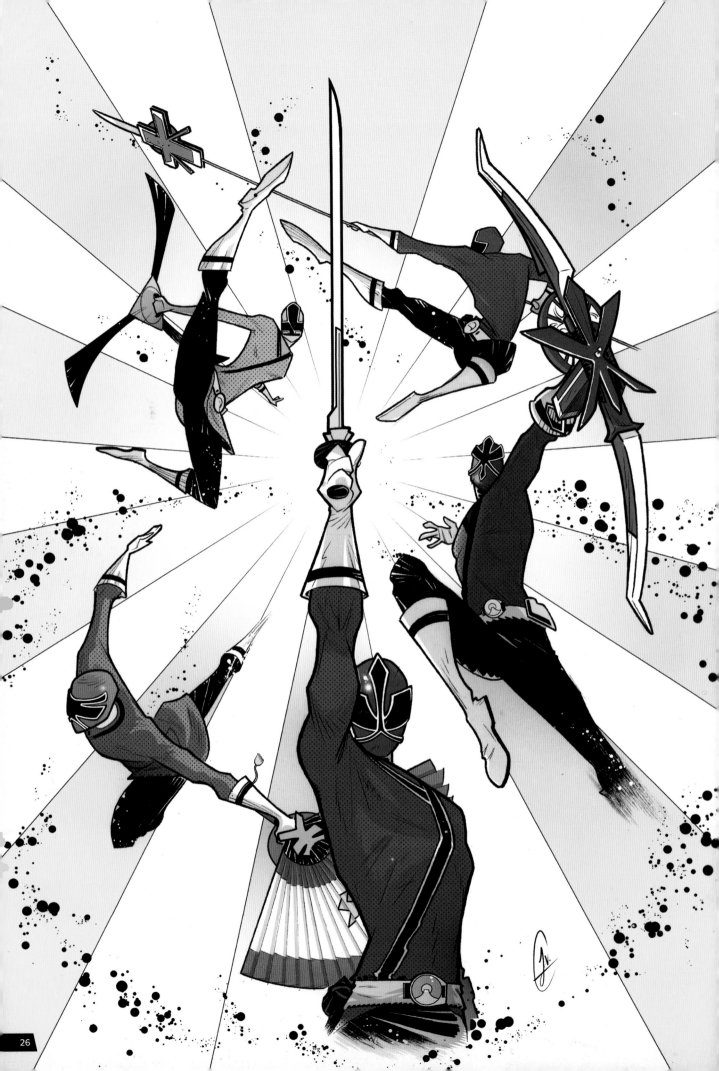

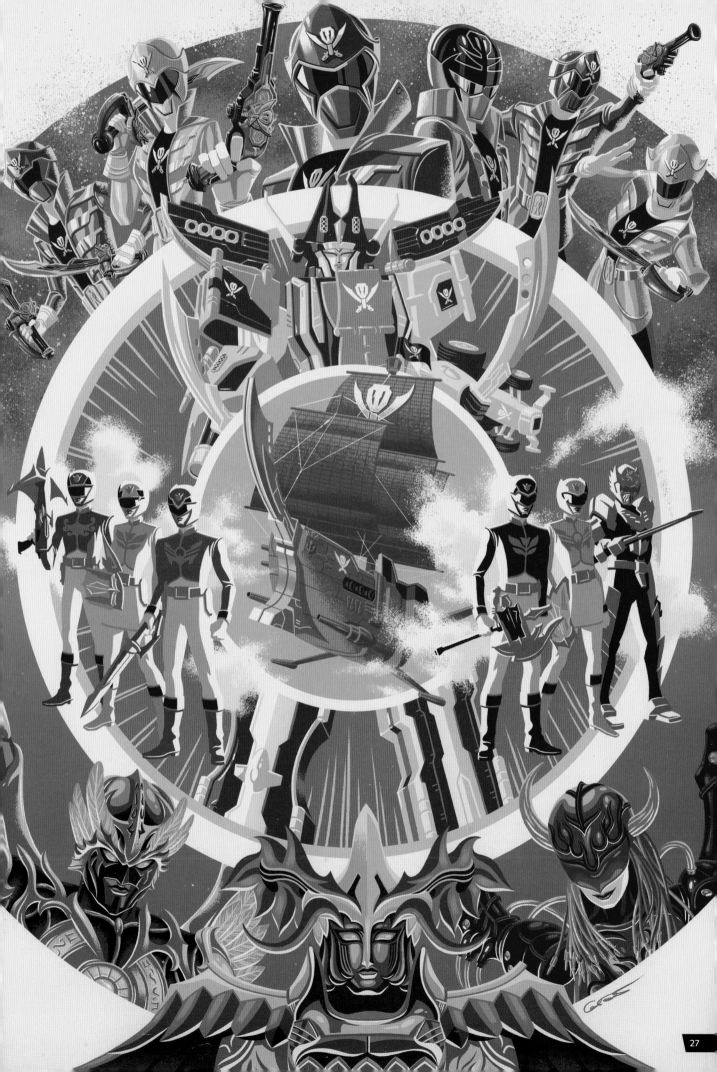

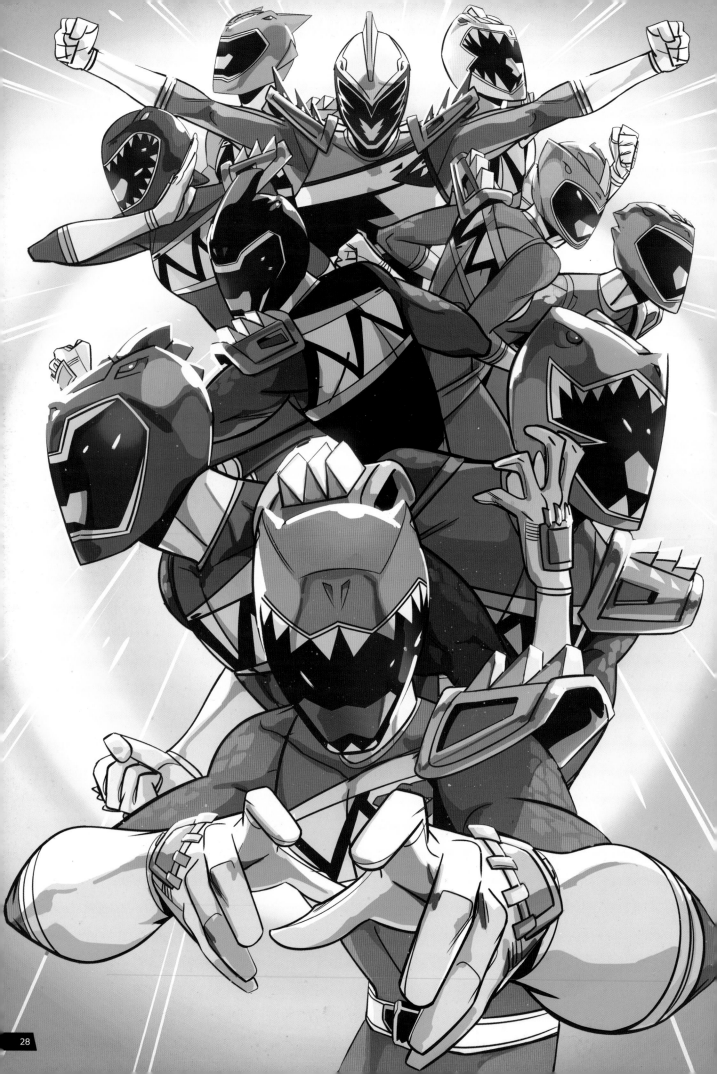

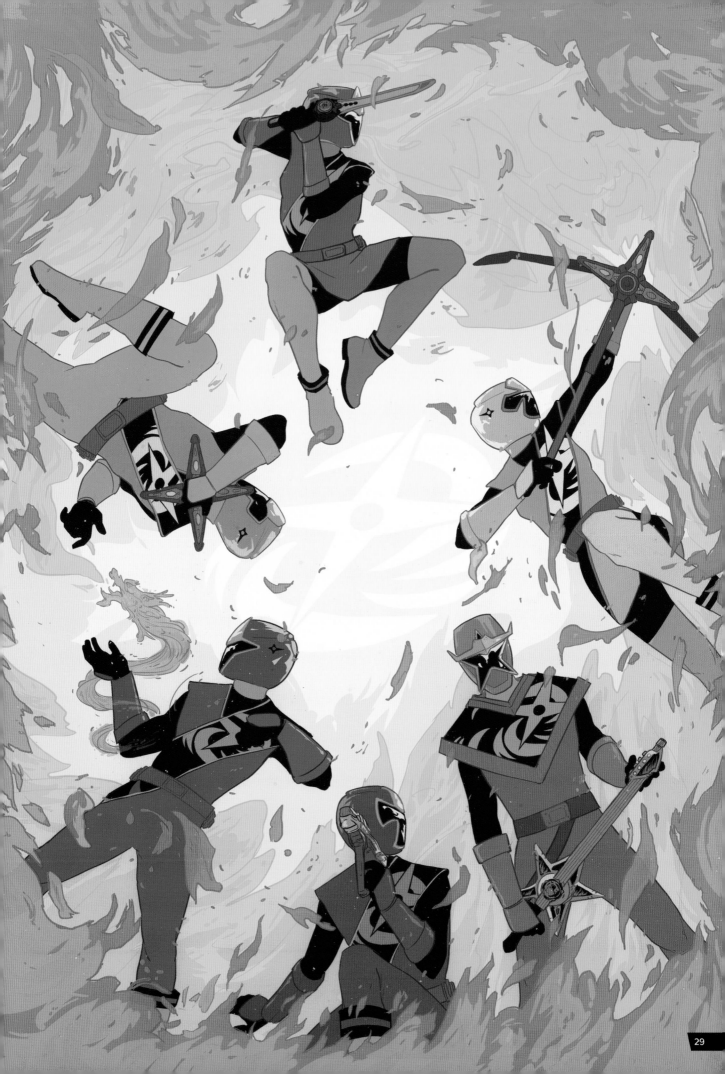

A REFLECTION

I feel that *Power Rangers* relates to many people on so many levels. The idea that anyone can be a hero is so ingrained in the show and a pillar of its longstanding success. In every episode, *Power Rangers* delivered a message that good prevails over evil, underdogs can win, and that doing the right thing is most important. I think the show provided a healthy escape for its viewers—an escape to a place where everything worked out not only in favor of the hero, but for the good of all.

> { *Power Rangers* delivered a message that good prevails over evil. }

The cast and crew worked hard to preserve this throughout my time on the show, and that message continues to resonate to this day. Even now, I have young crew members come up to me after they find out I worked on *Power Rangers* for as long as I did and tell me they grew up on the show and it's message. I feel proud to be a part of its legacy.

Danielle Baker

Costume Designer:
Mighty Morphin Power Rangers
Power Rangers Zeo
Power Rangers Turbo
Power Rangers in Space
Power Rangers Lost Galaxy
Power Rangers Lightspeed Rescue
Power Rangers Time Force
Power Rangers Wild Force

October 2017

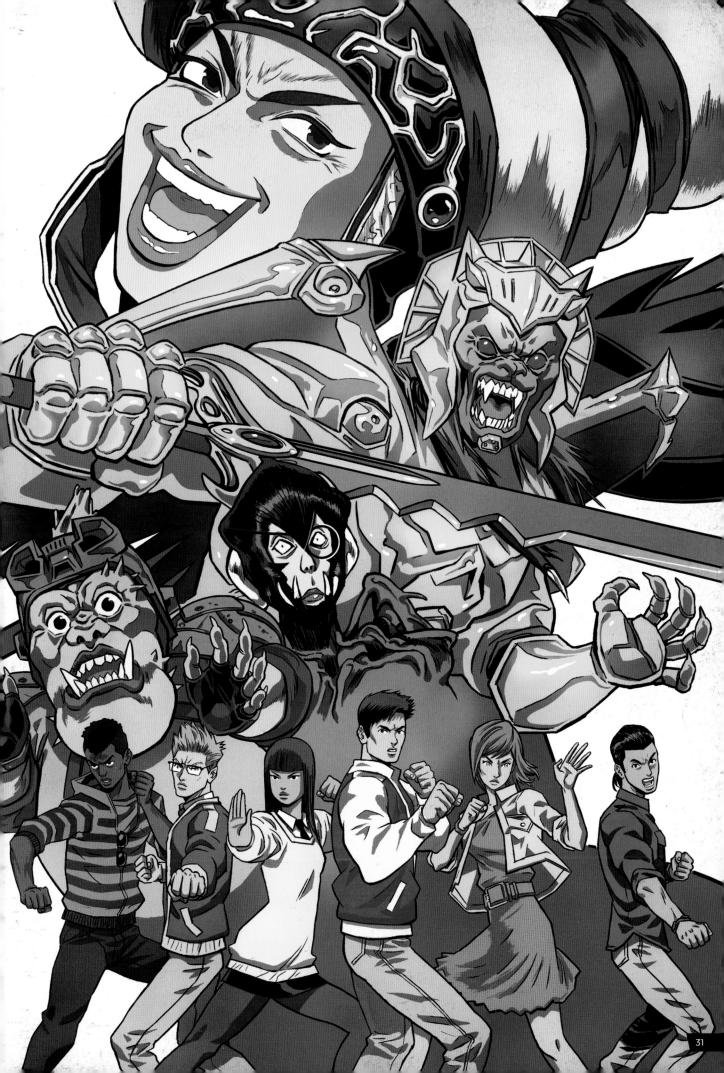

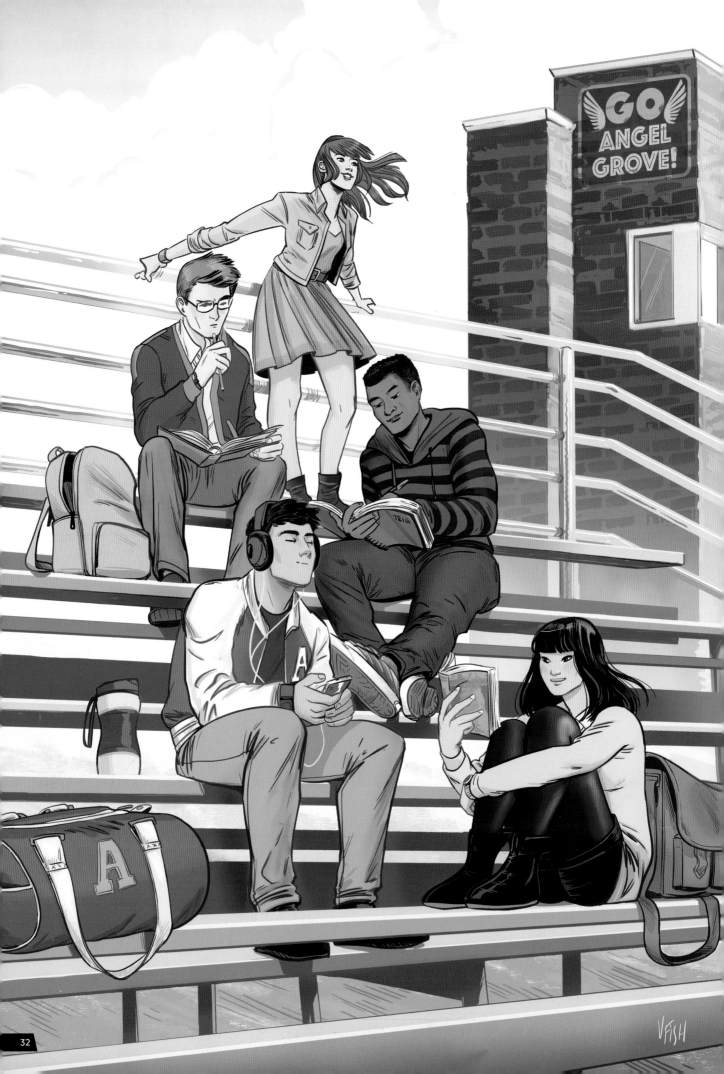

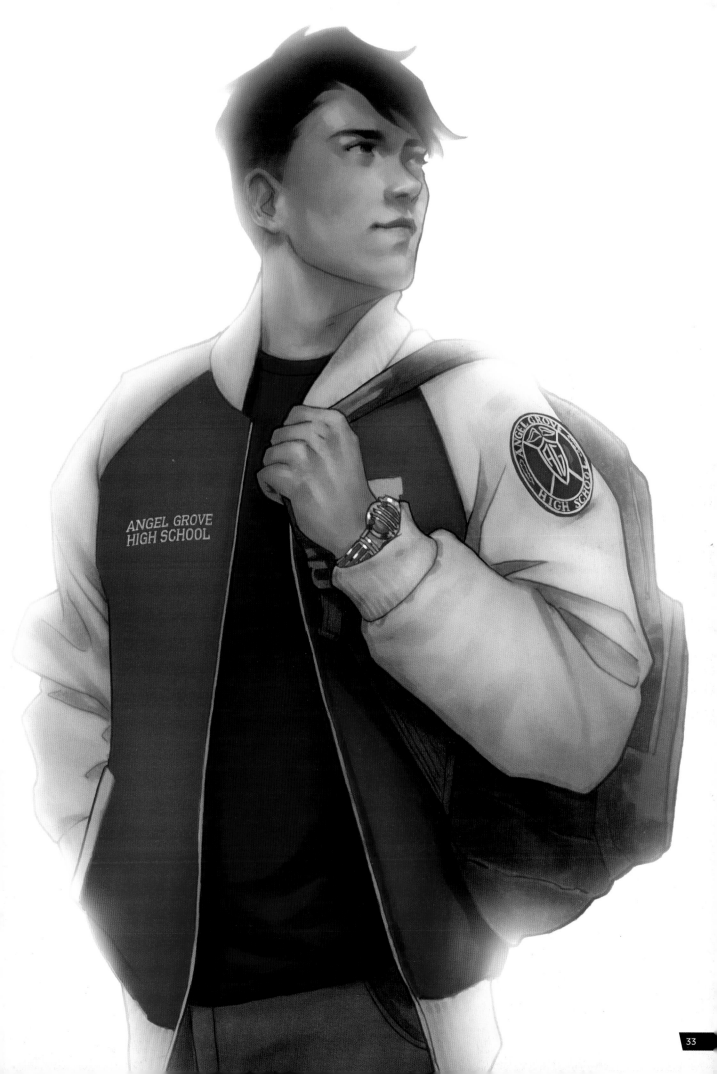

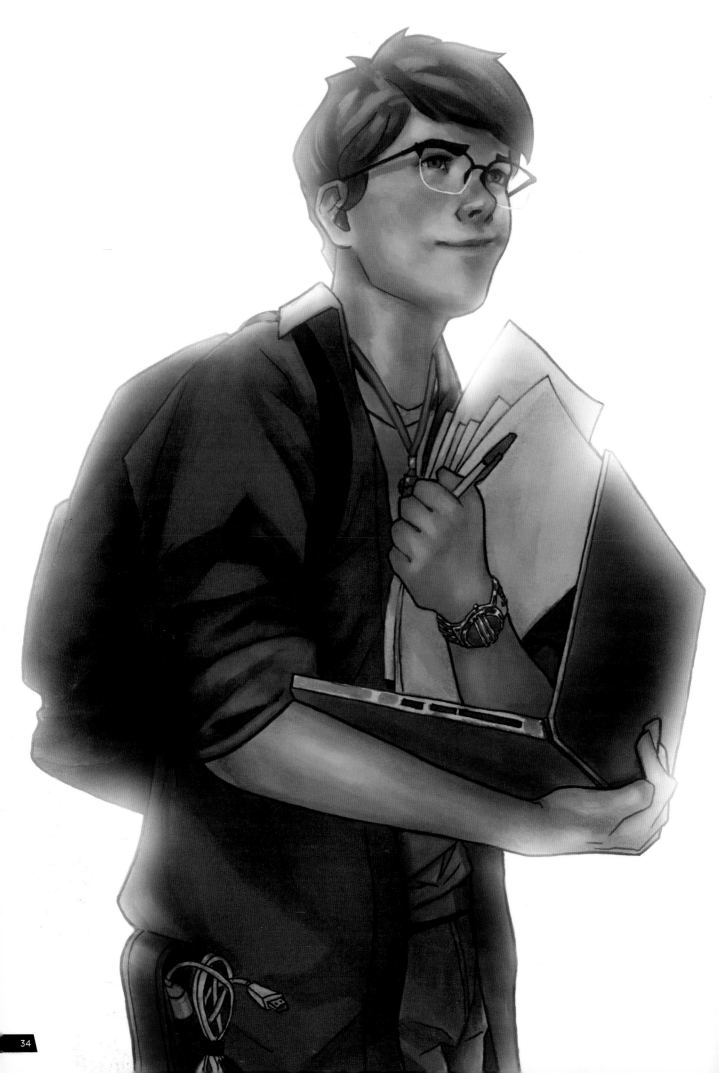

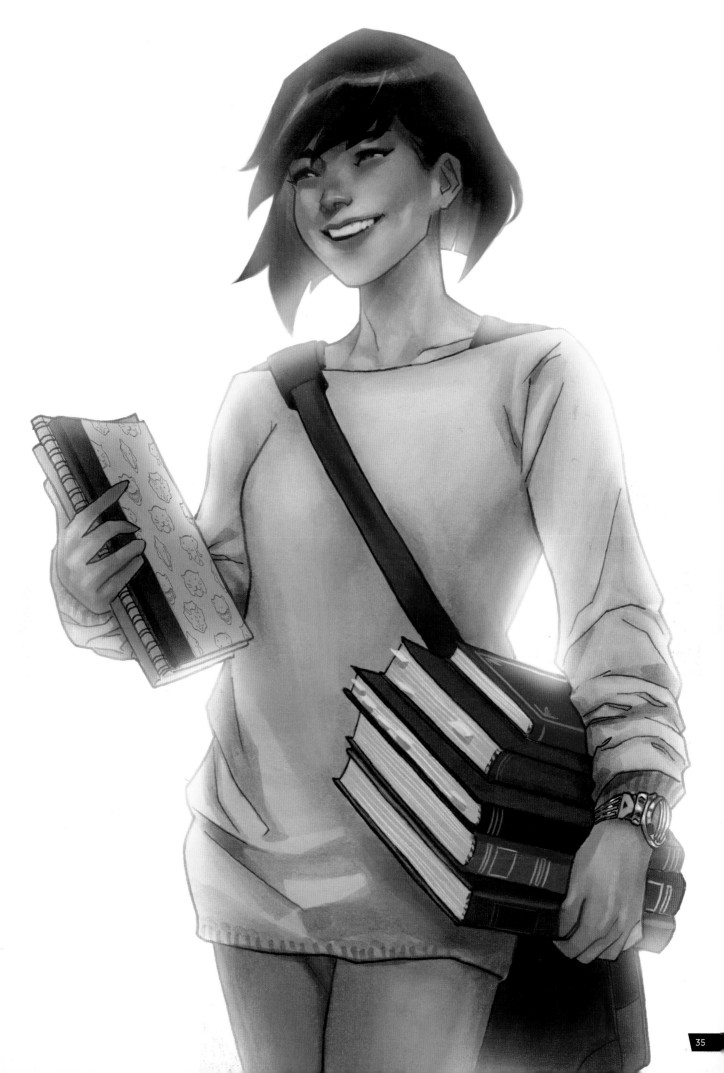

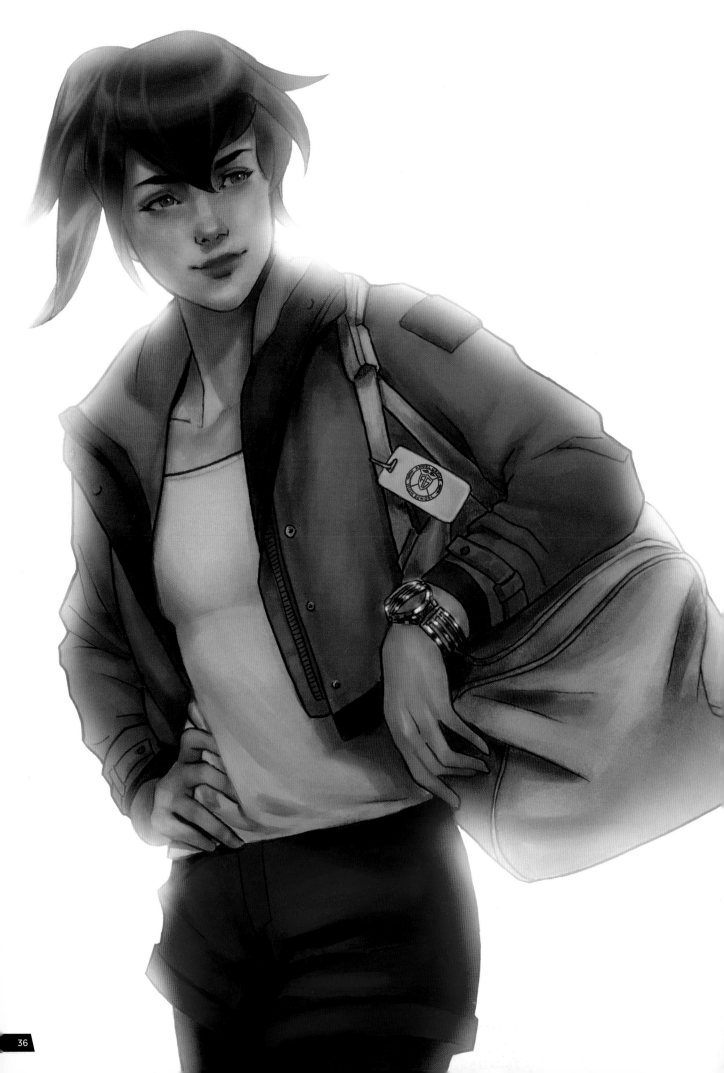

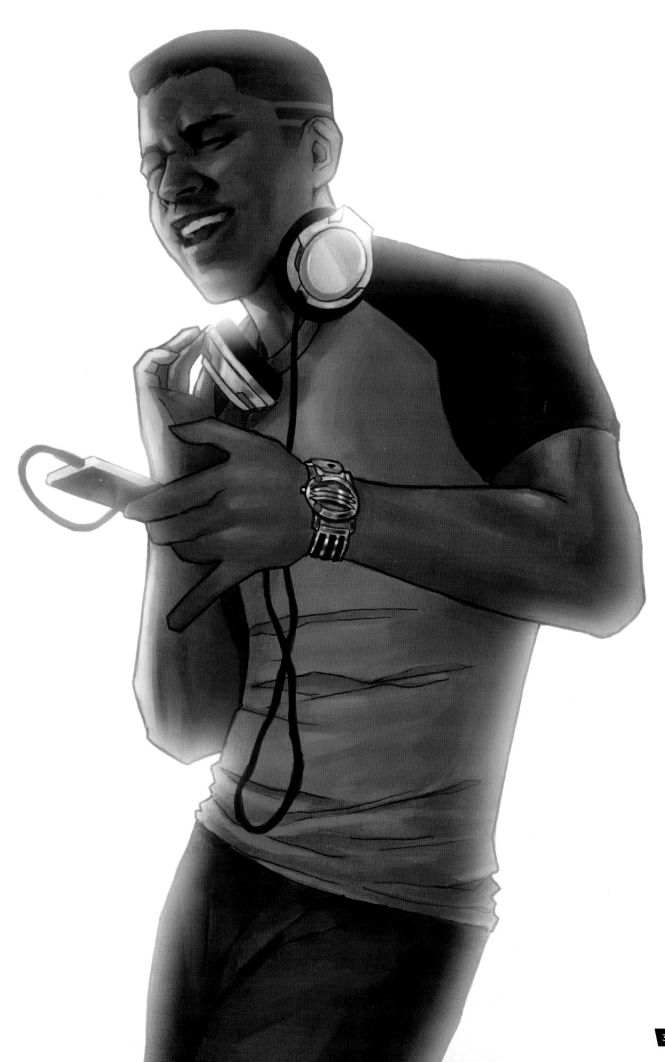

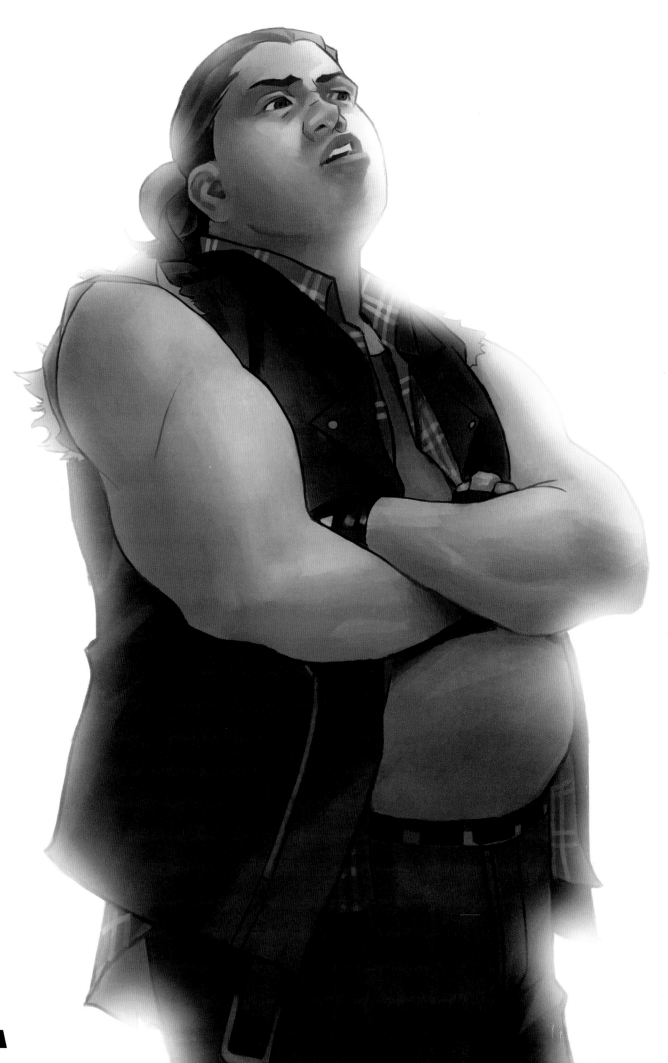

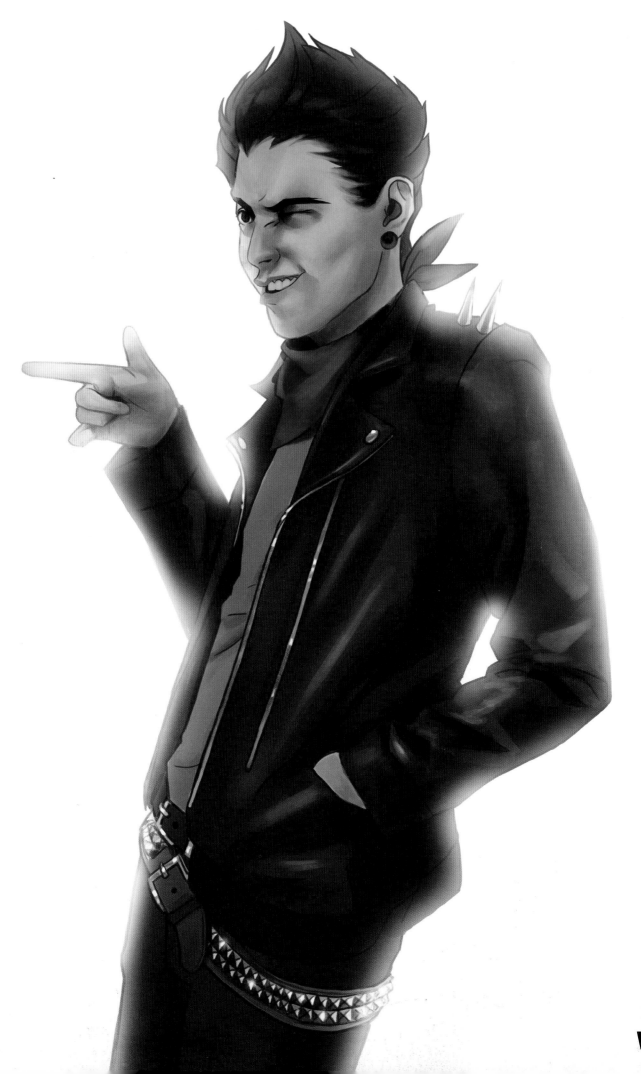

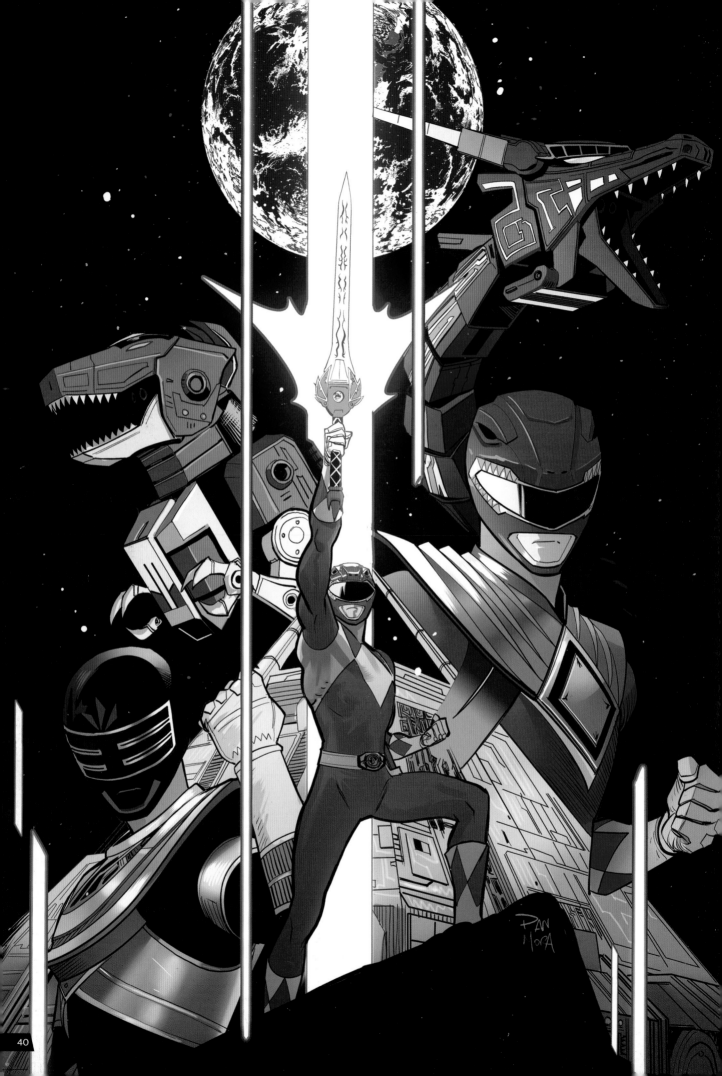

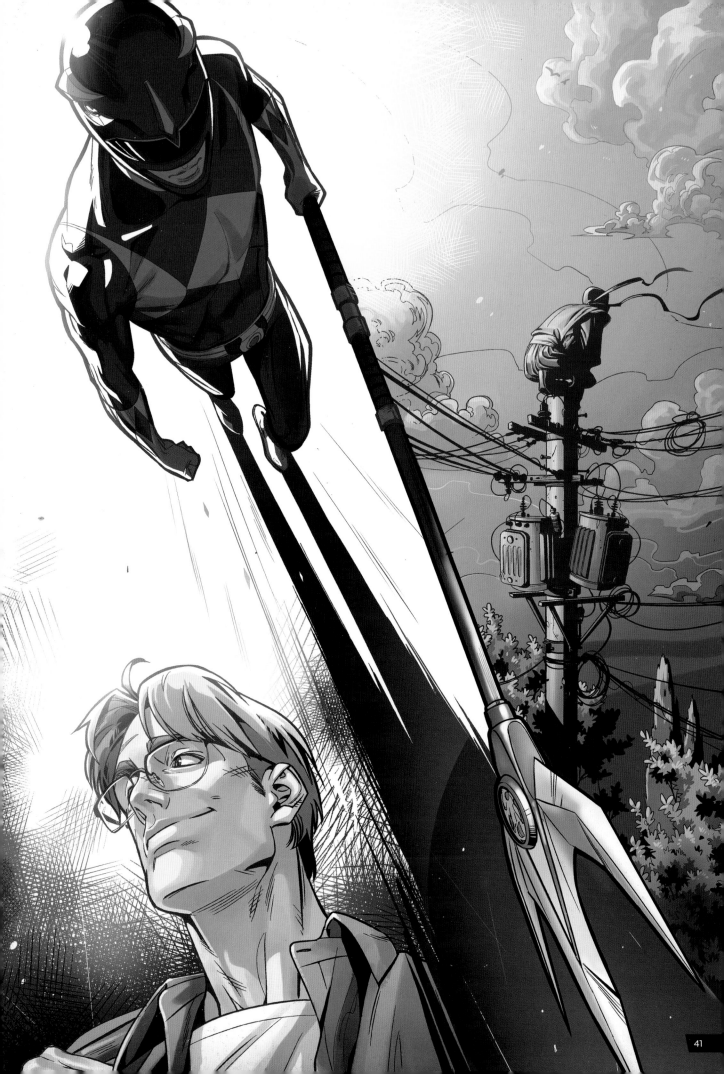

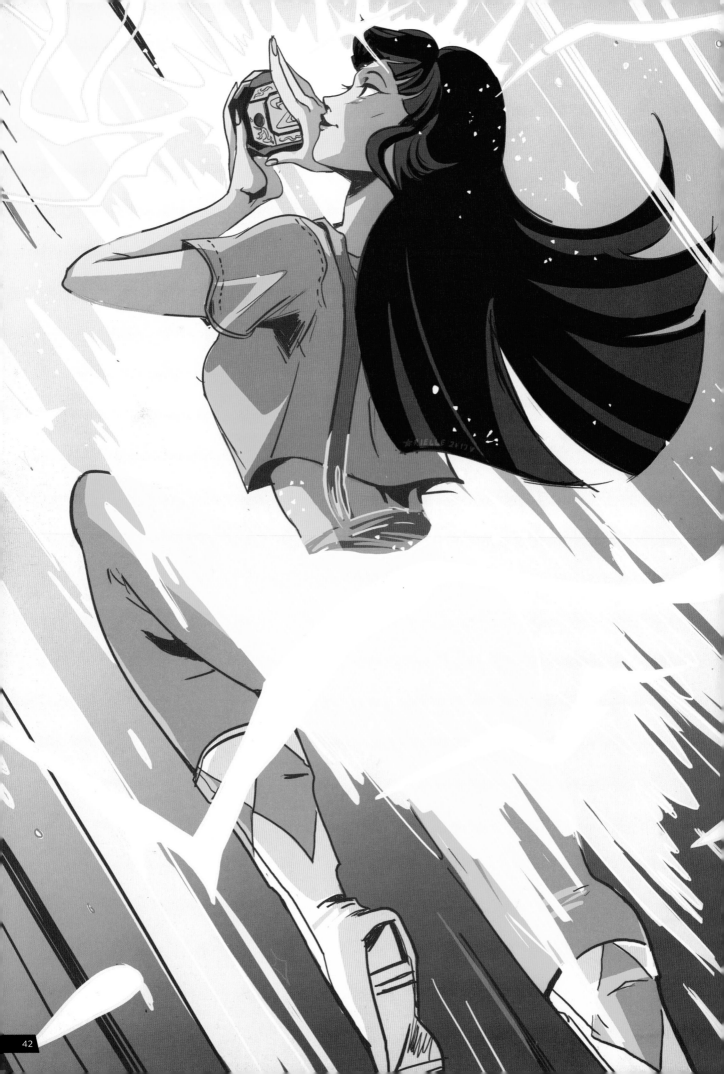

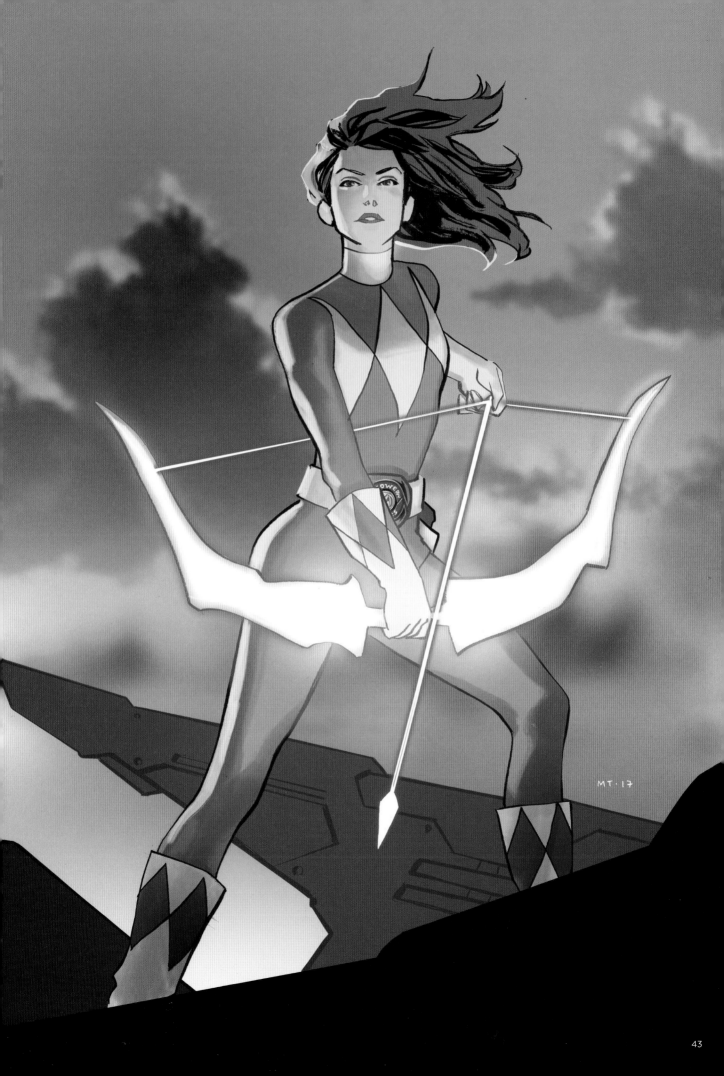

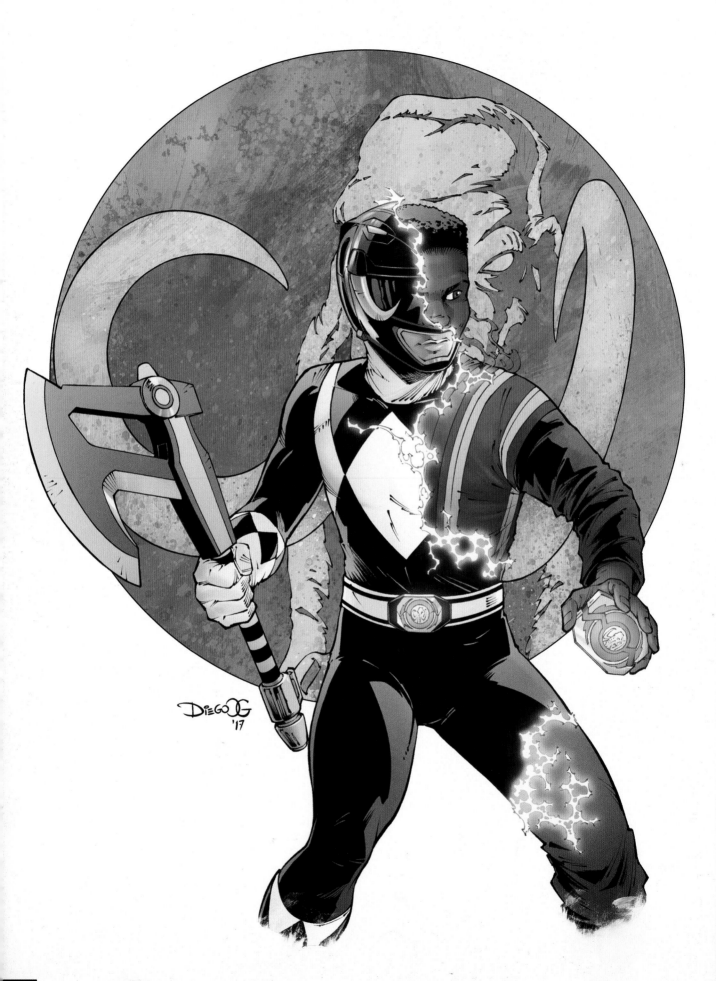

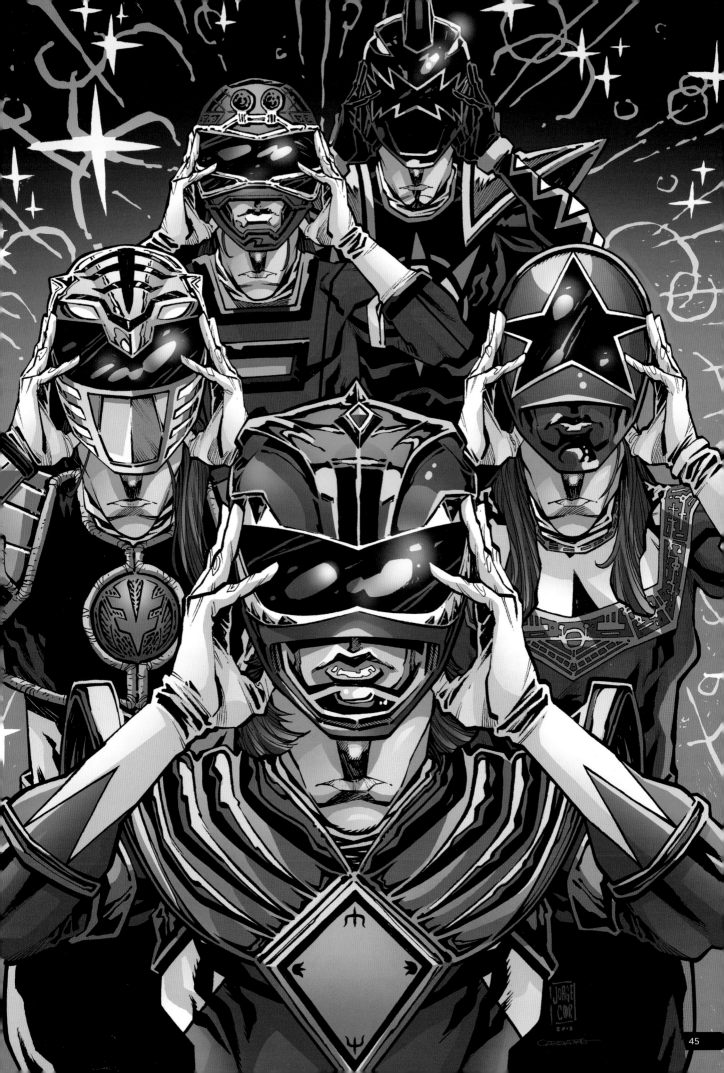

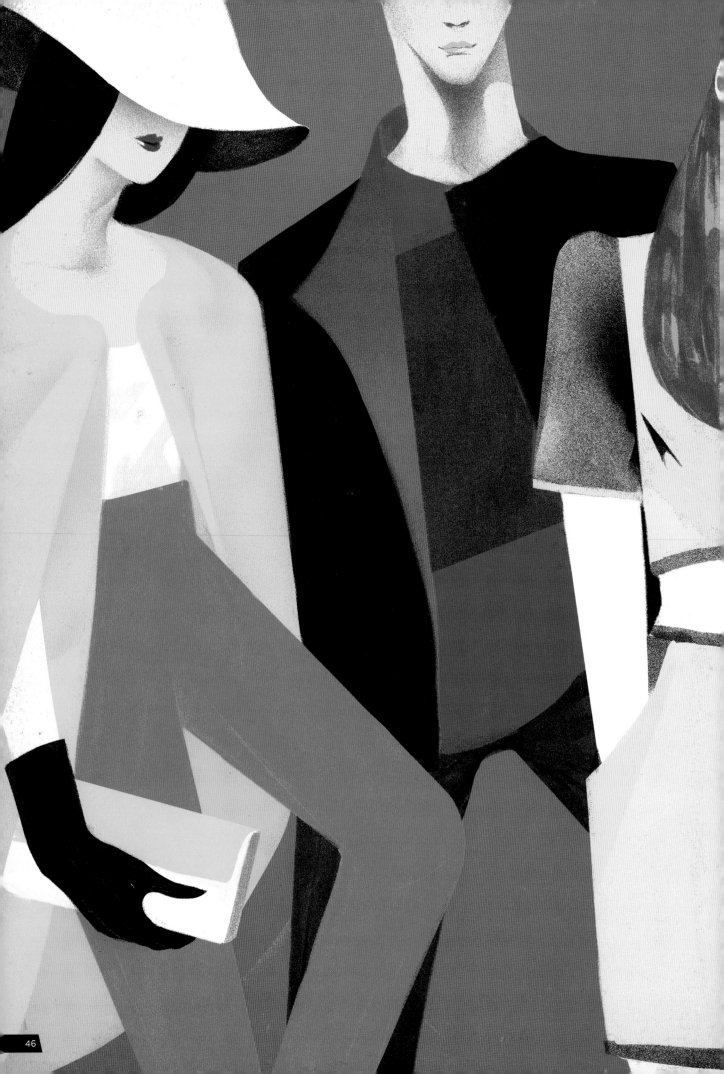

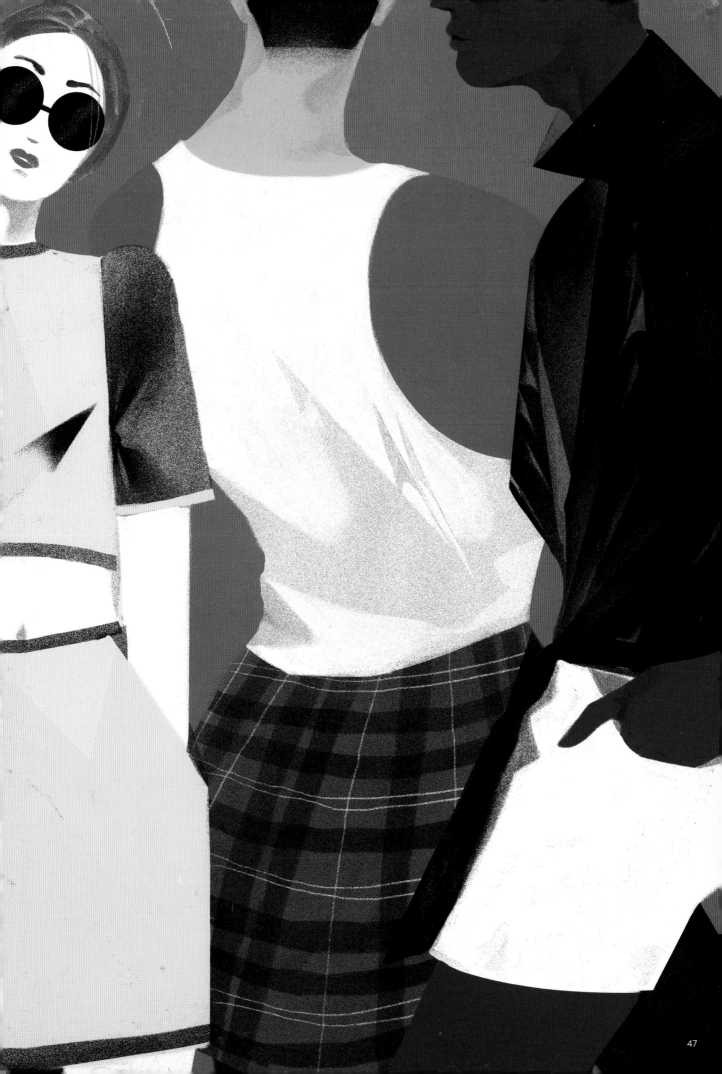

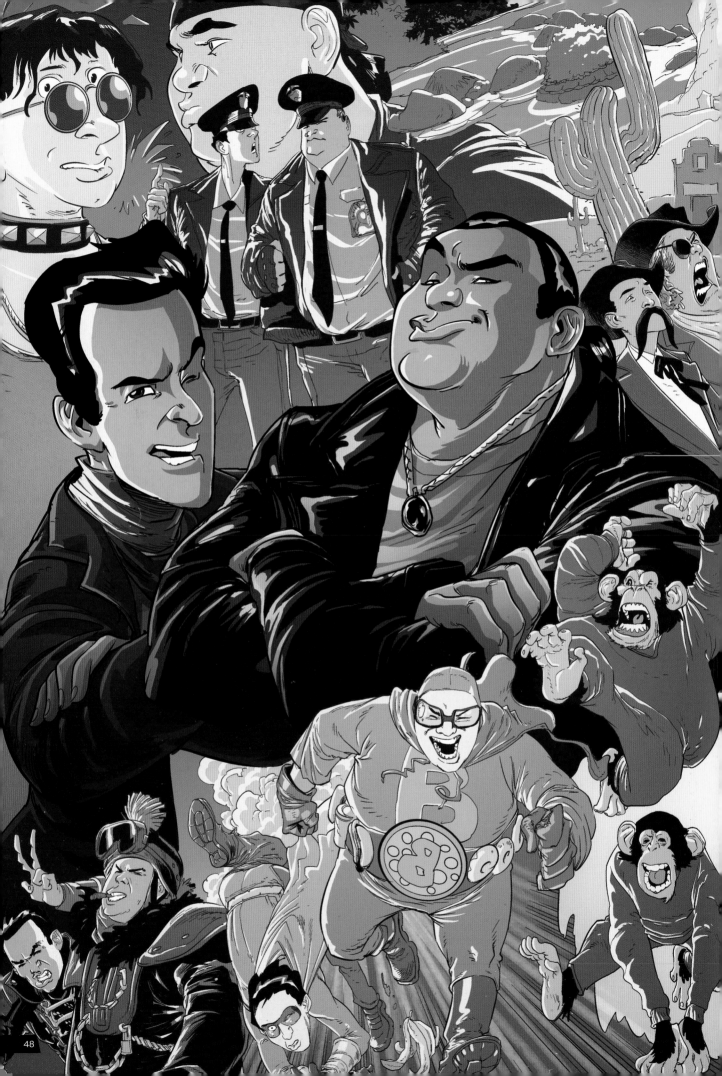

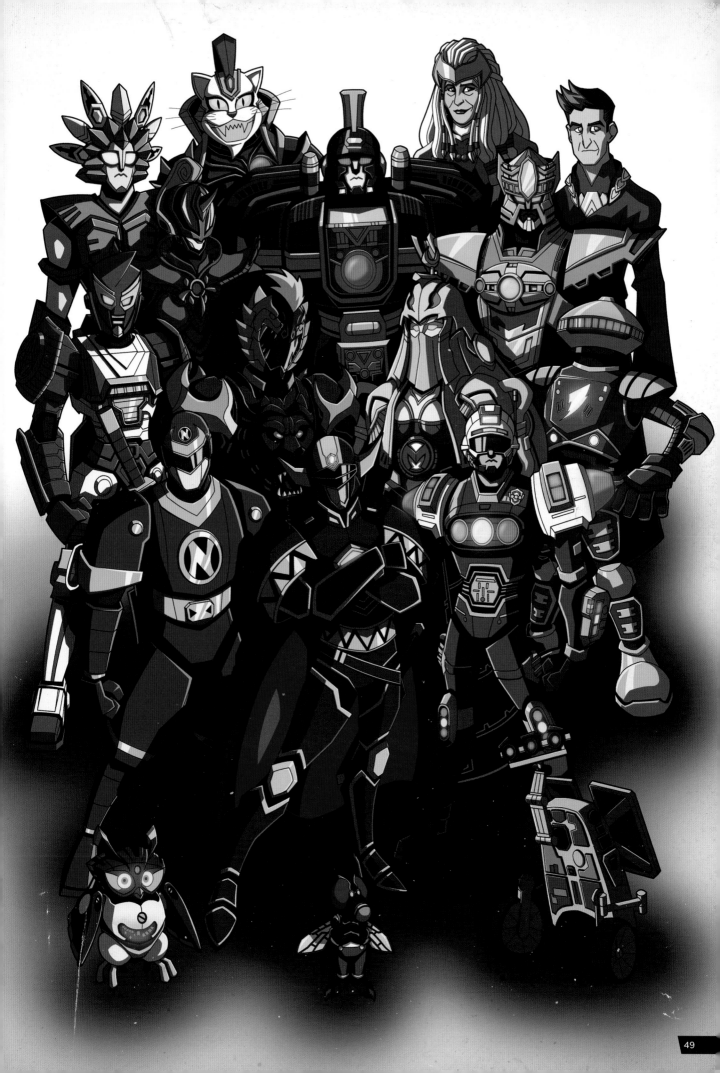

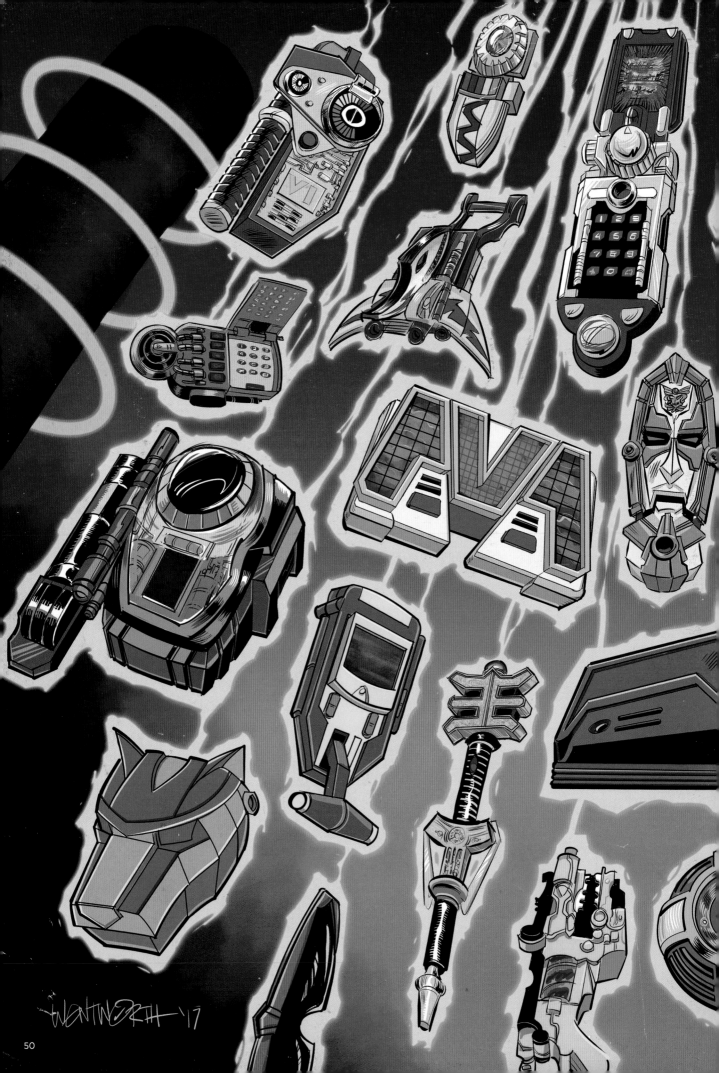

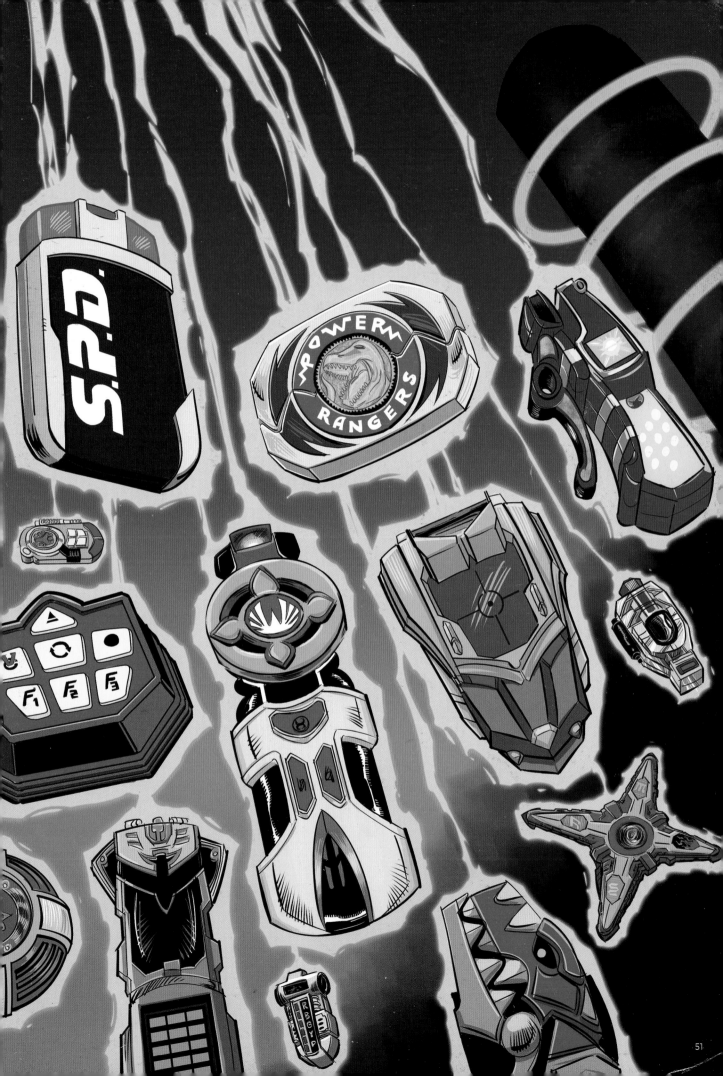

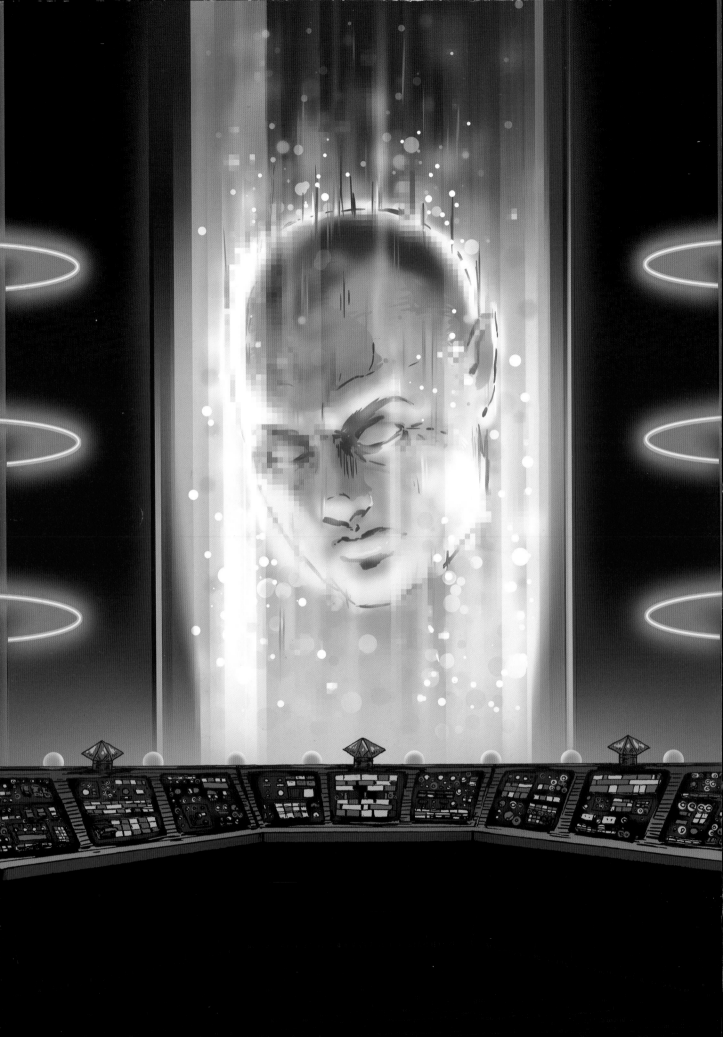

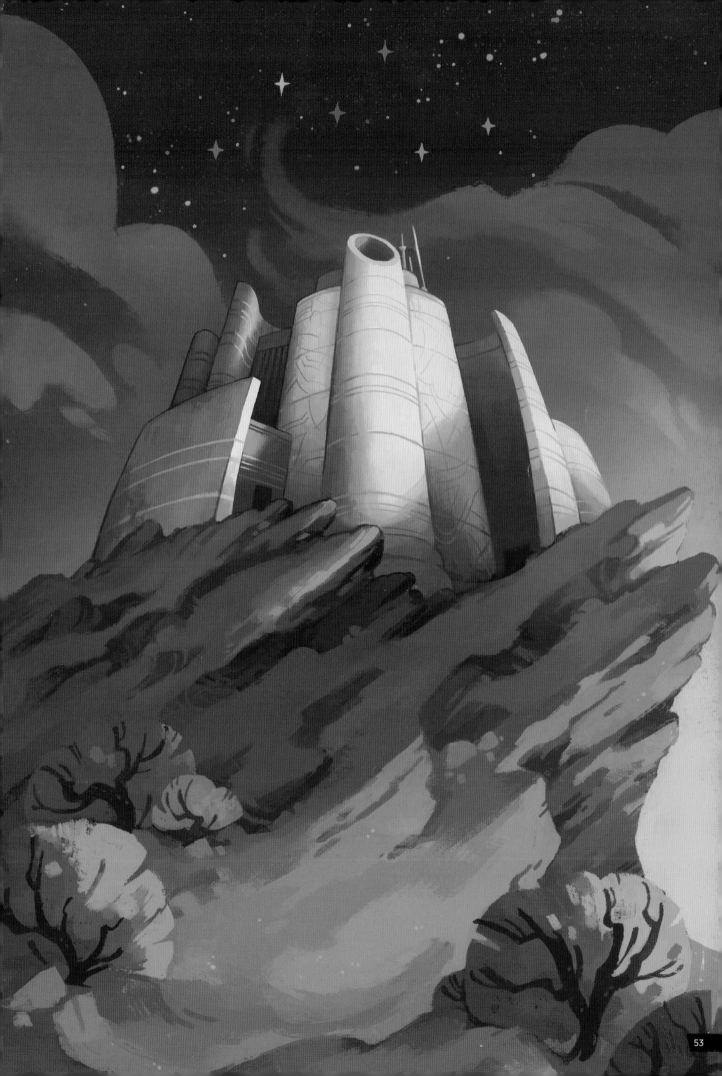

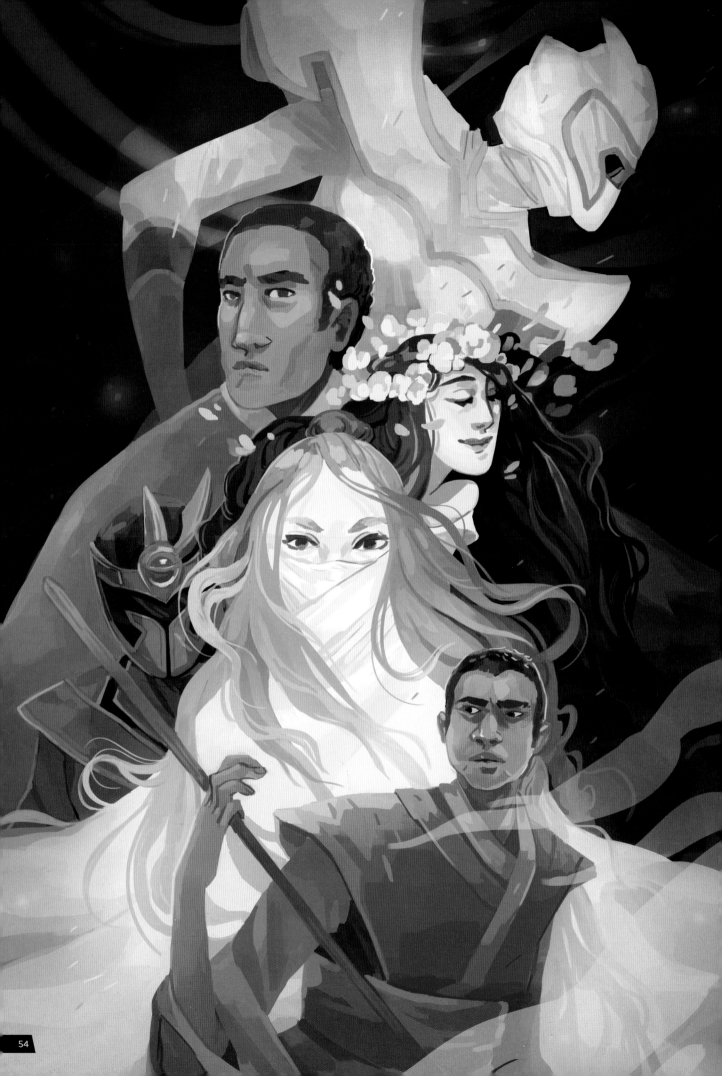

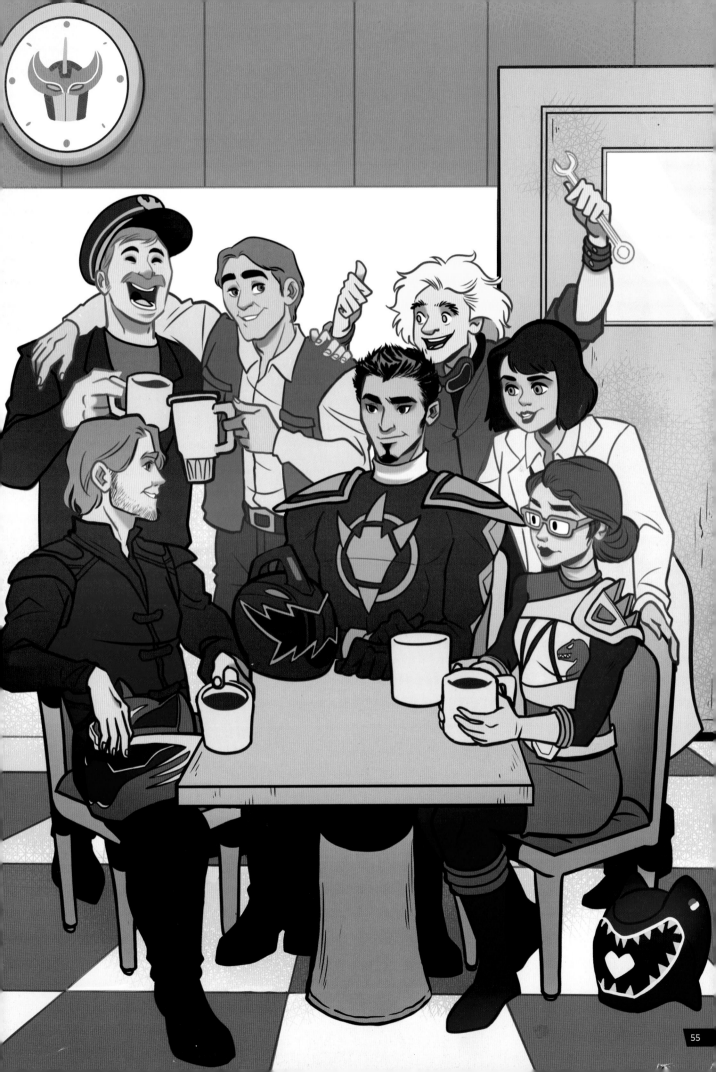

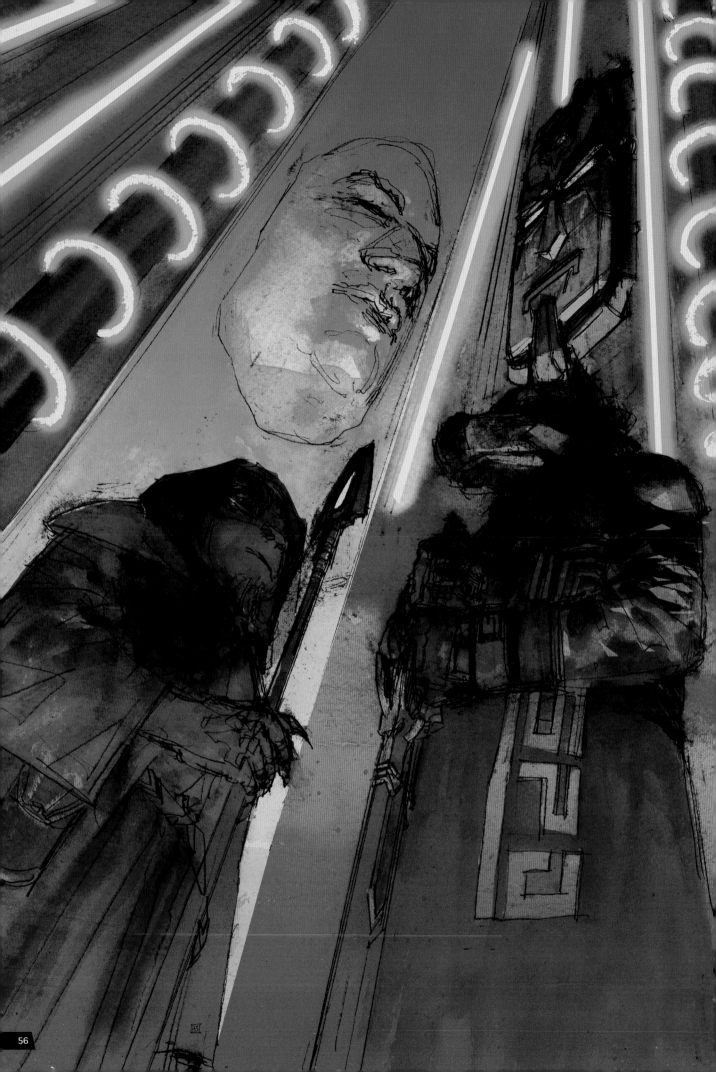

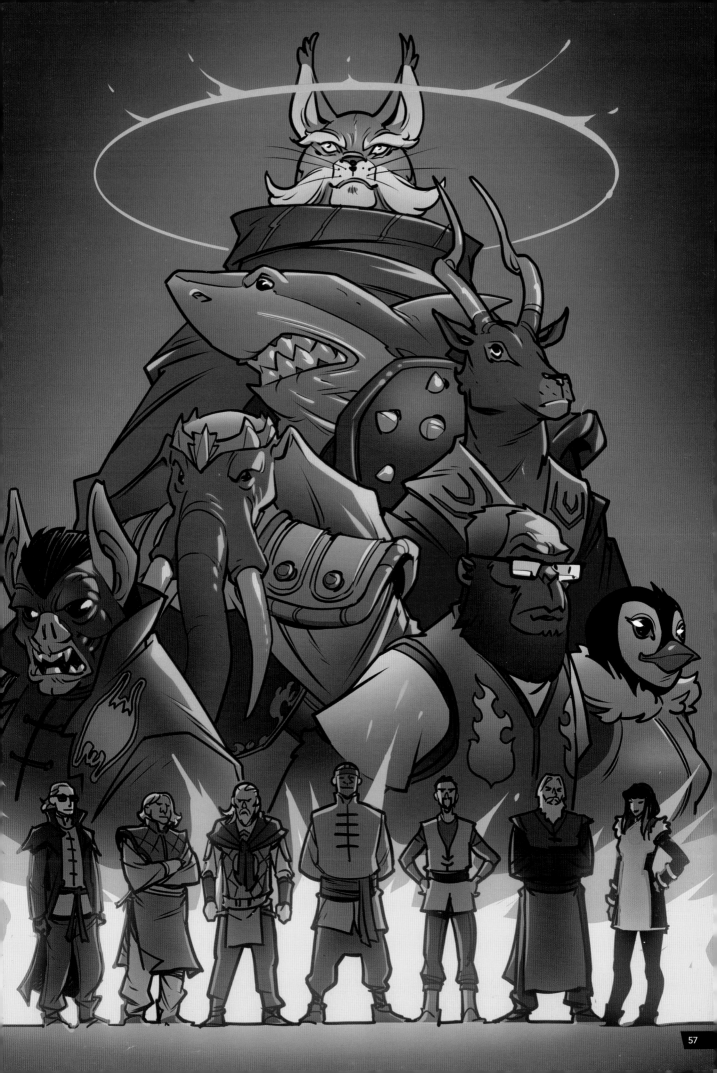

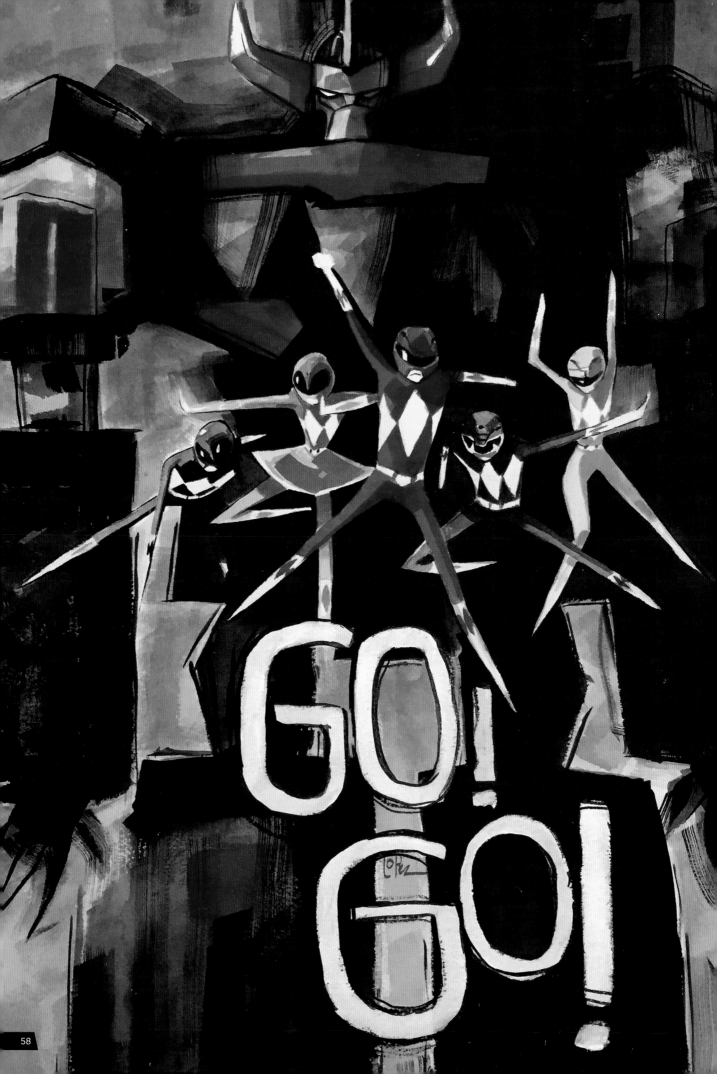

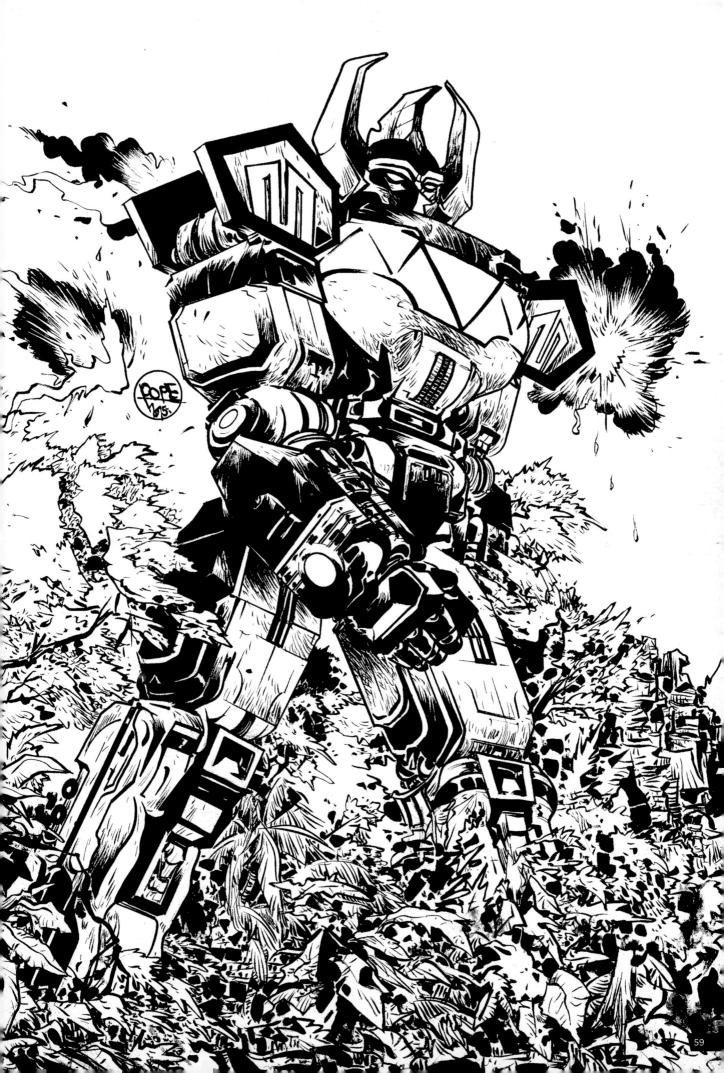

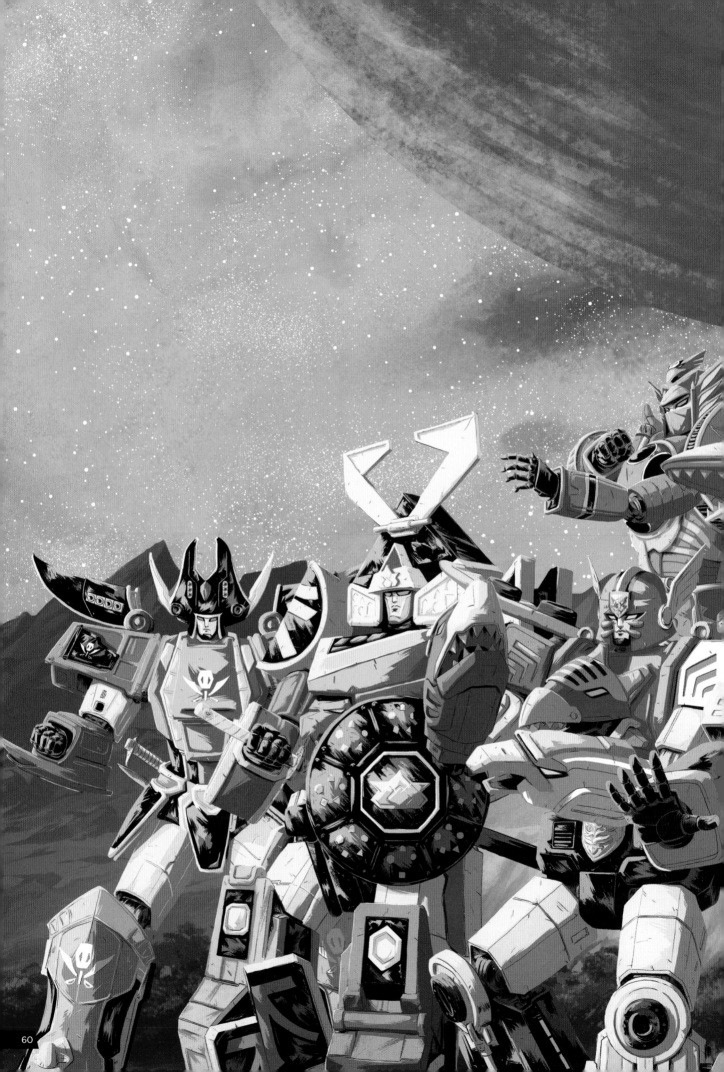

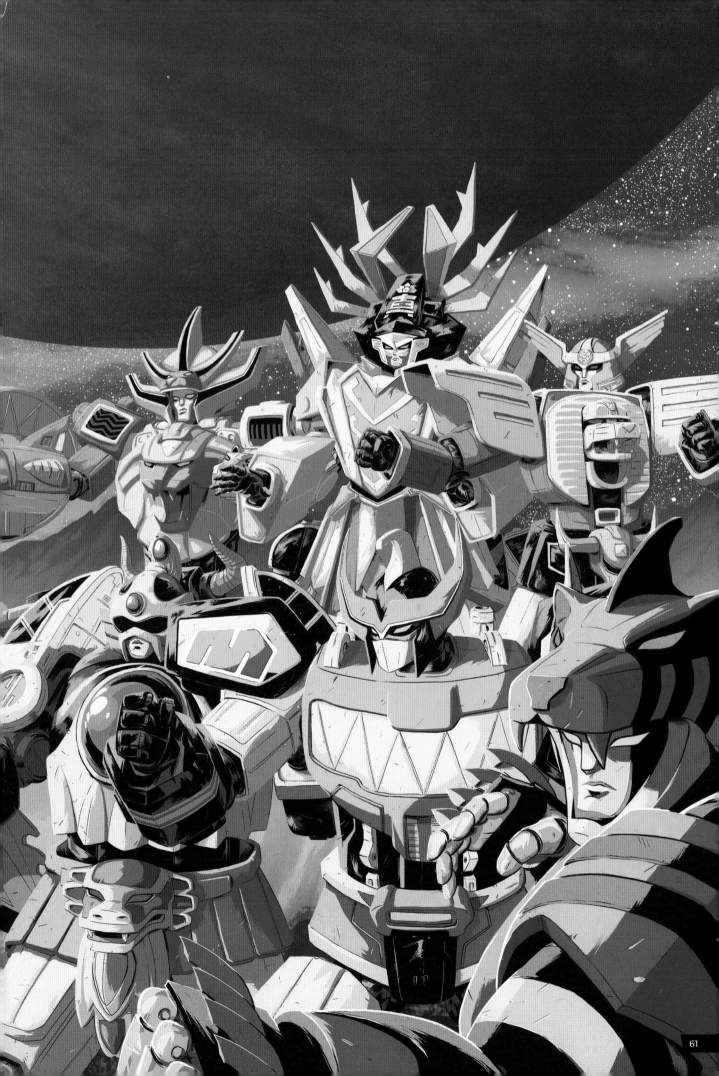

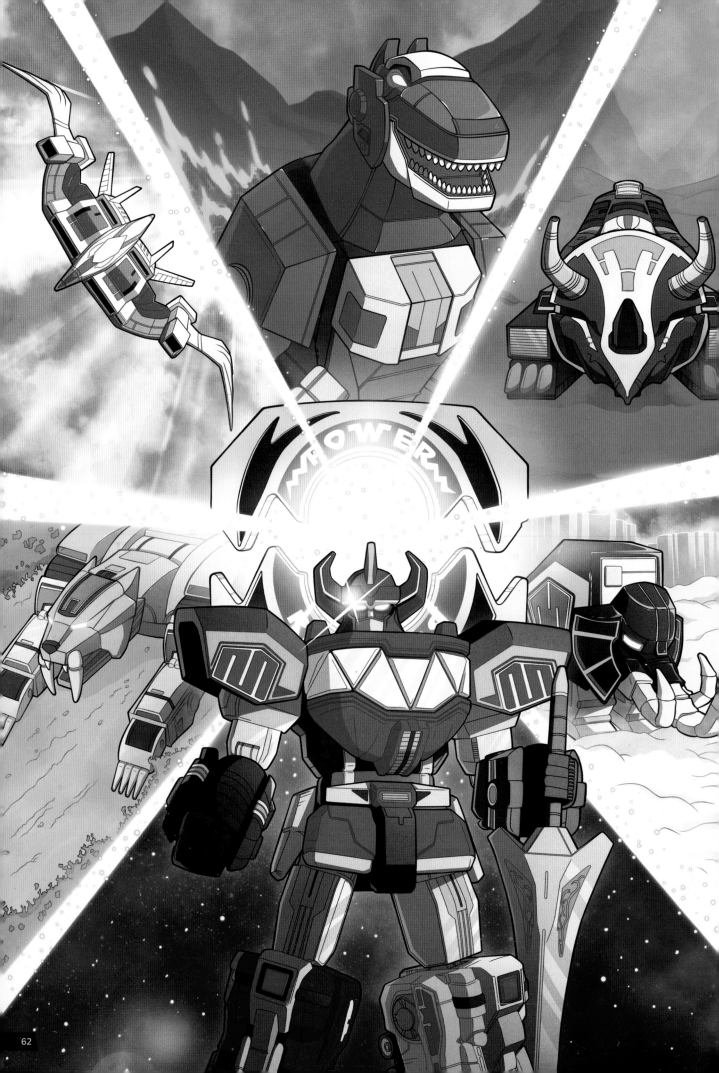

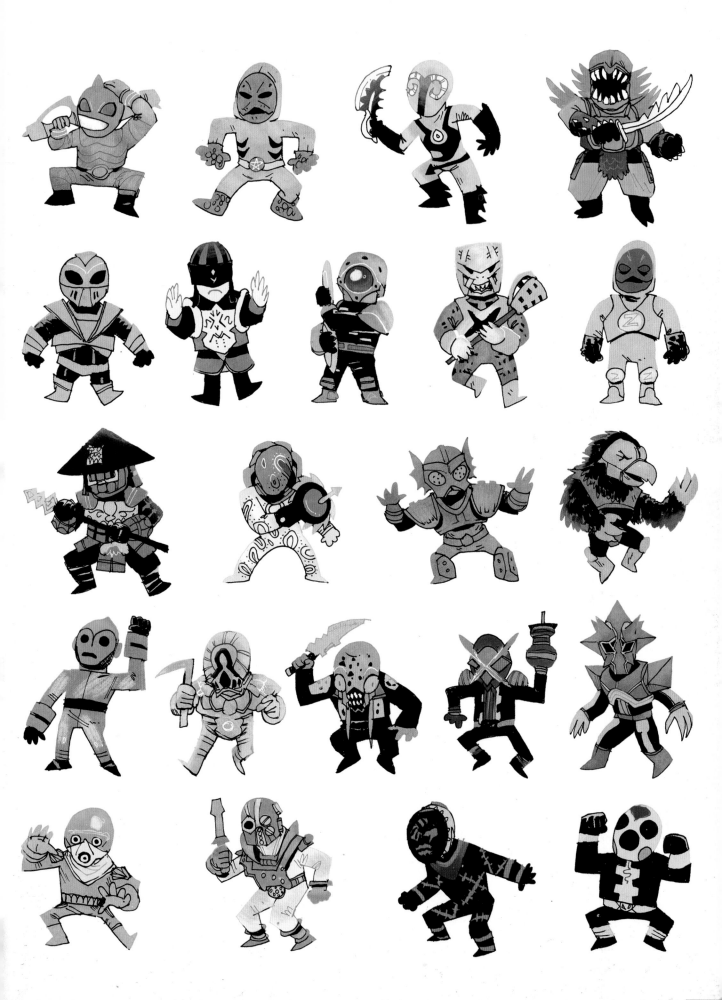

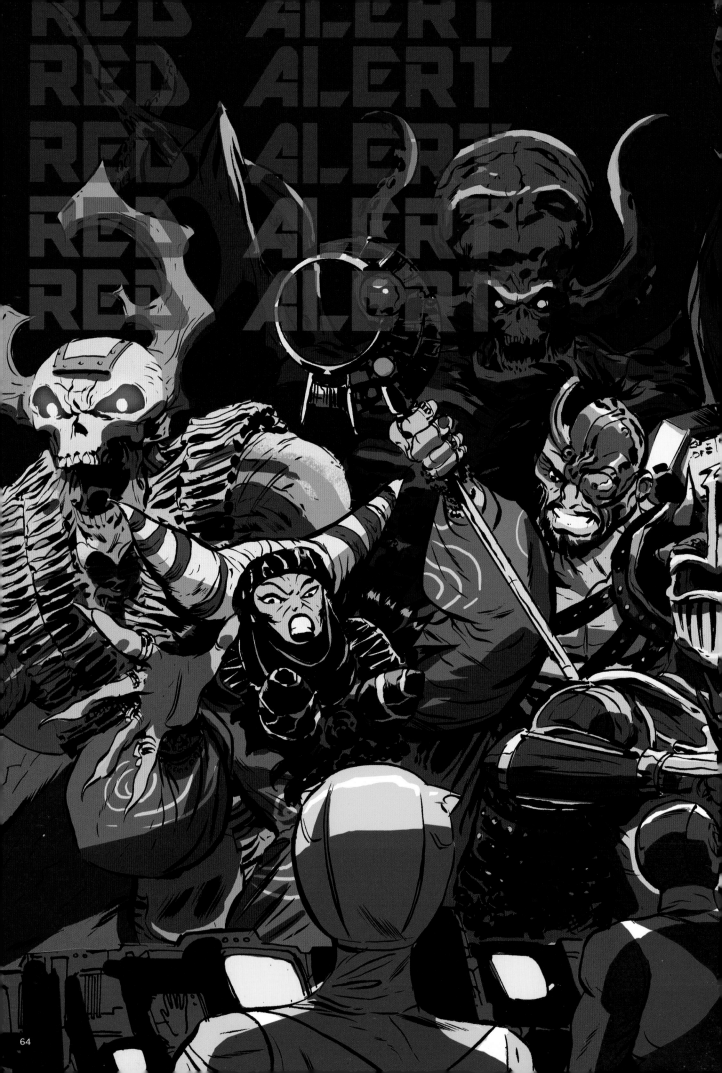

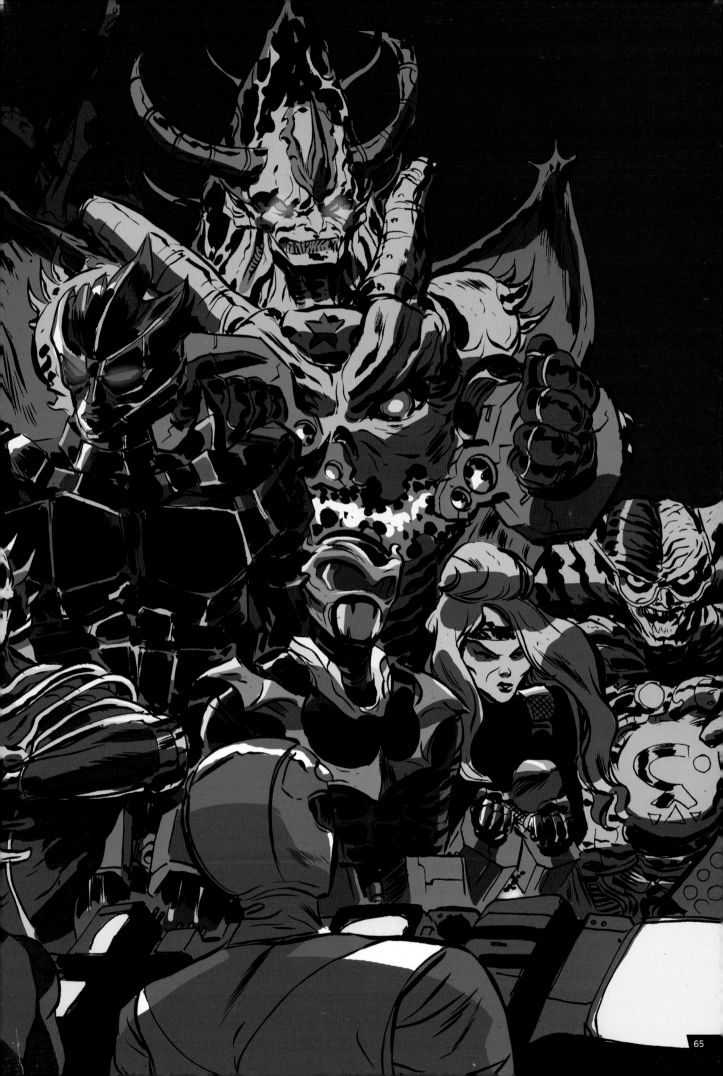

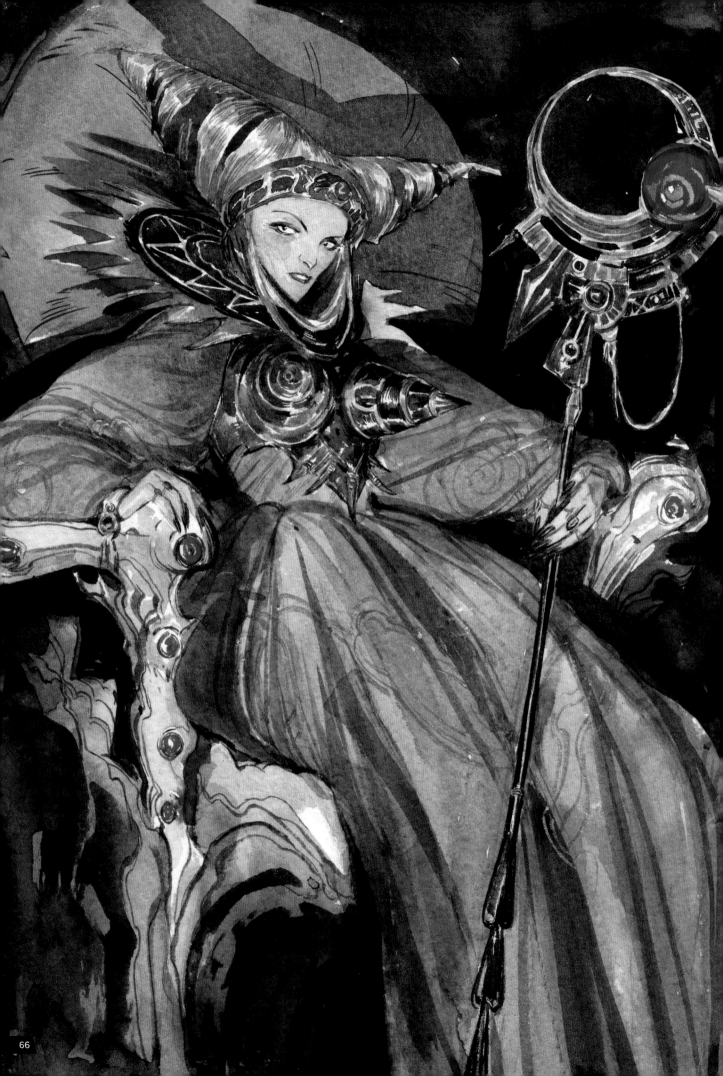

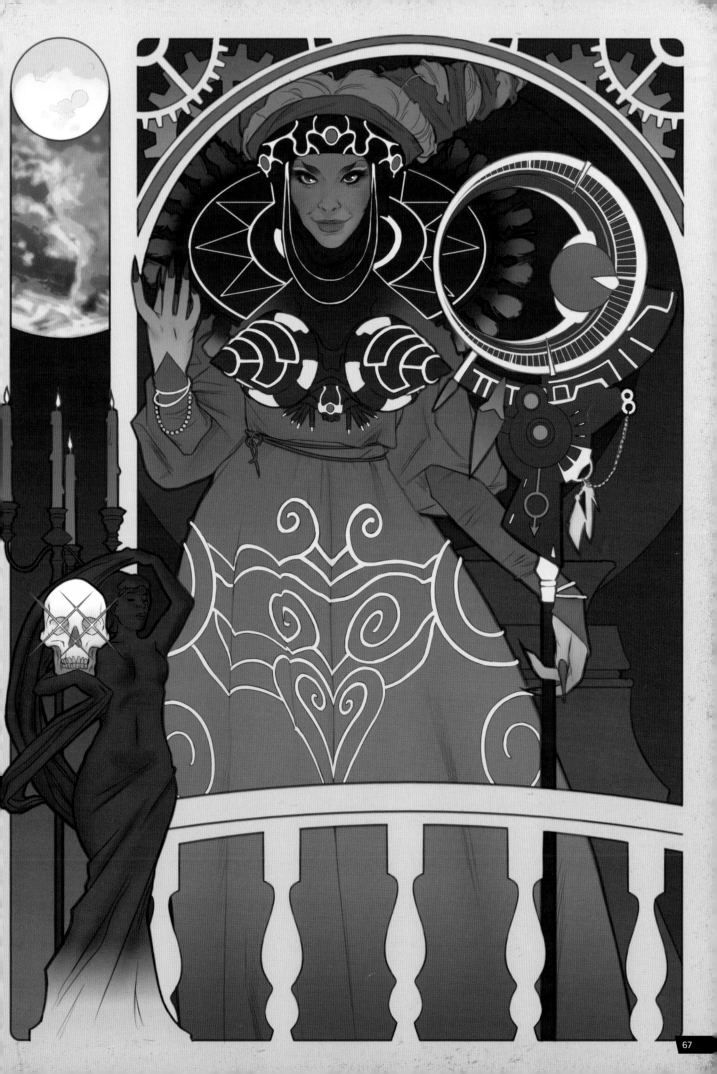

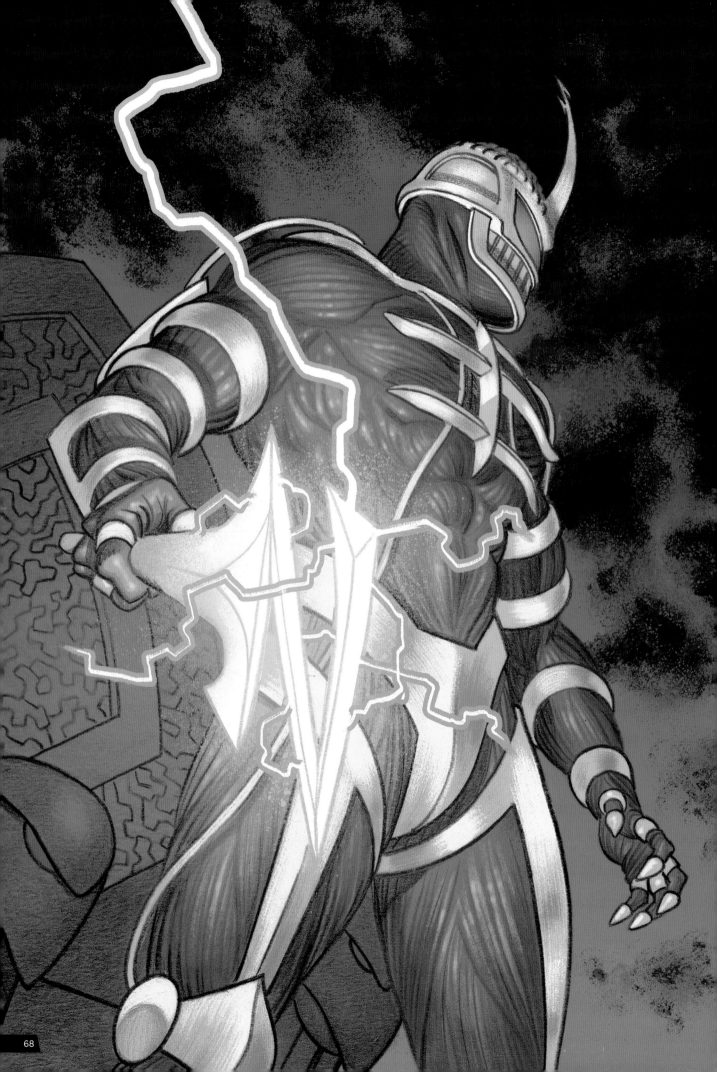

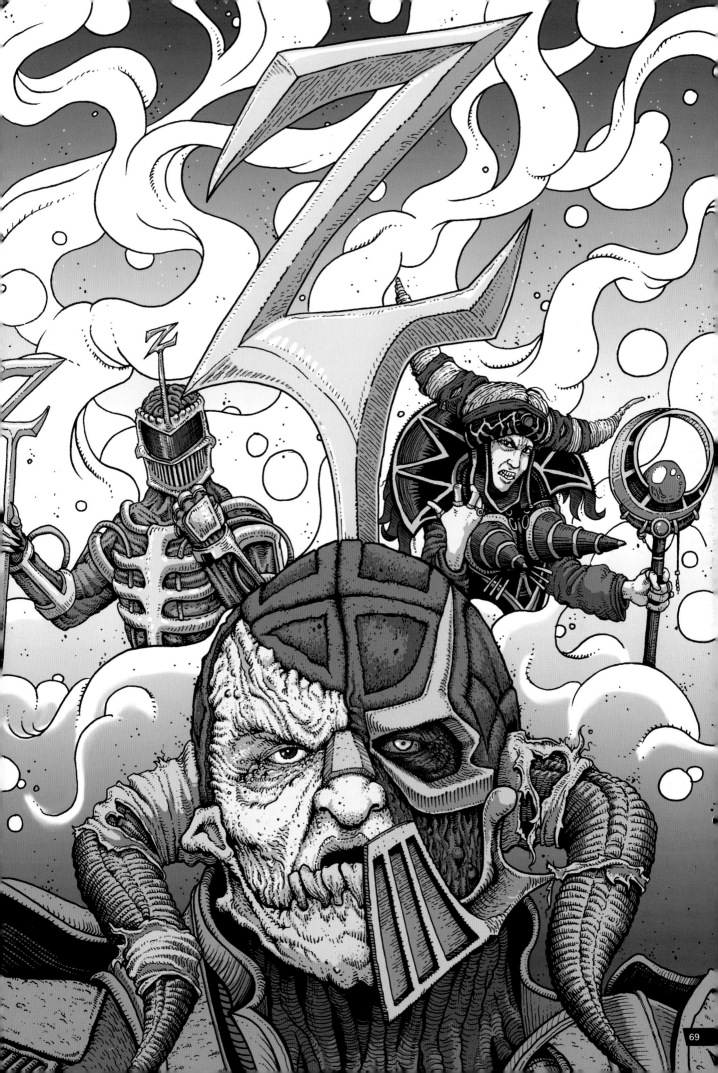

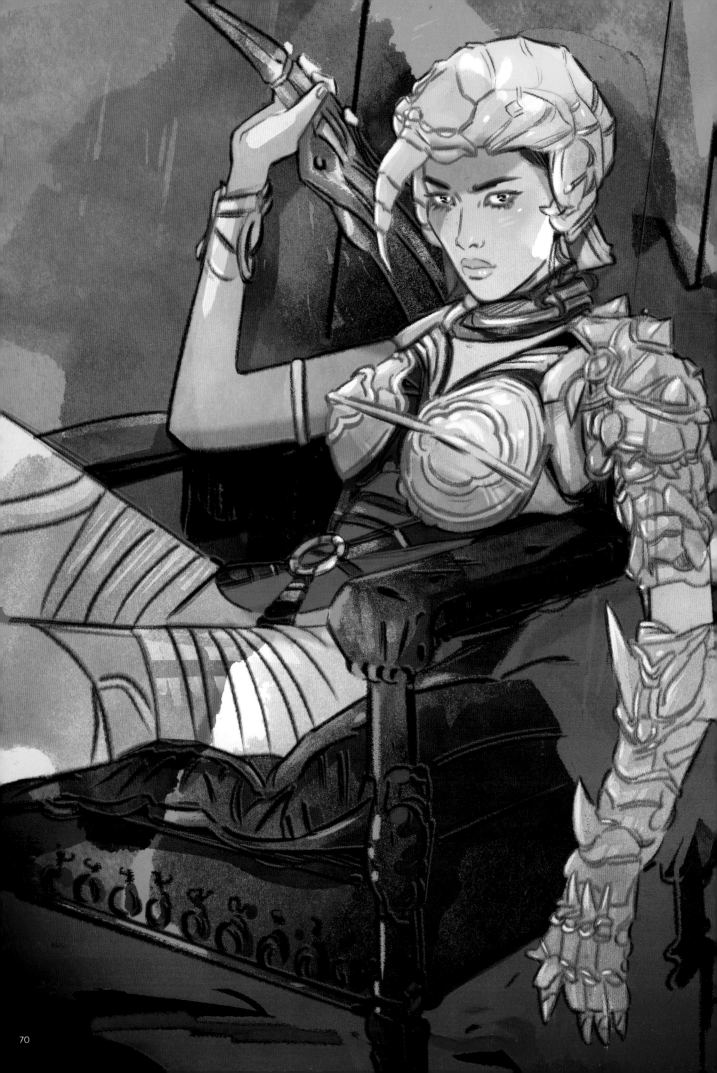

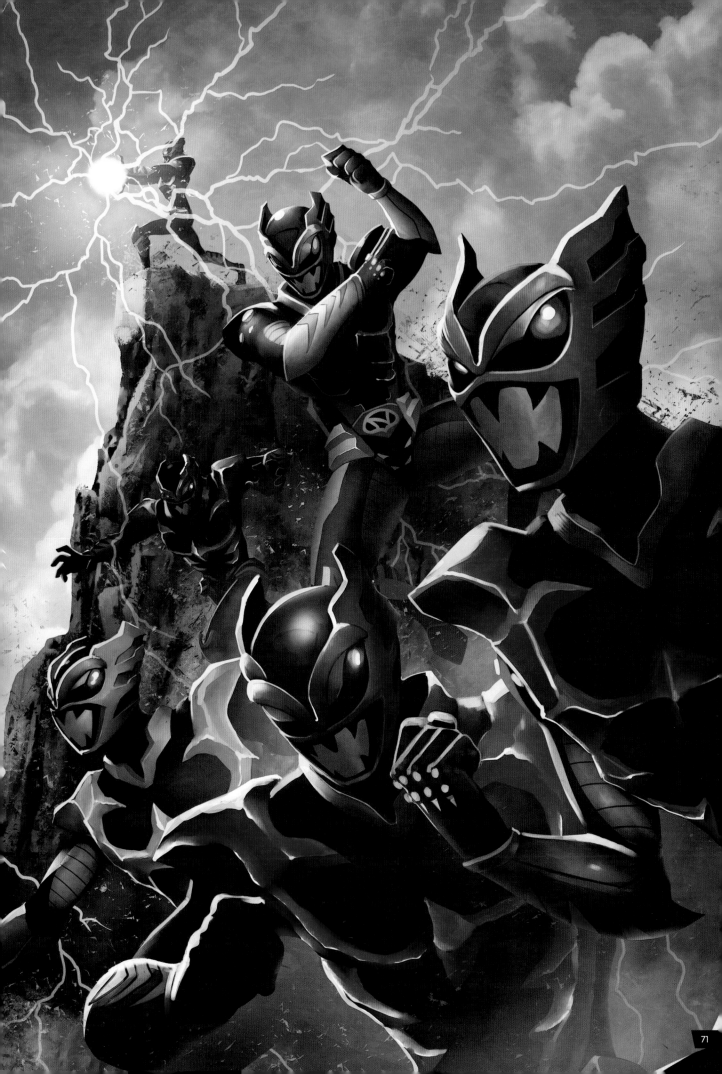

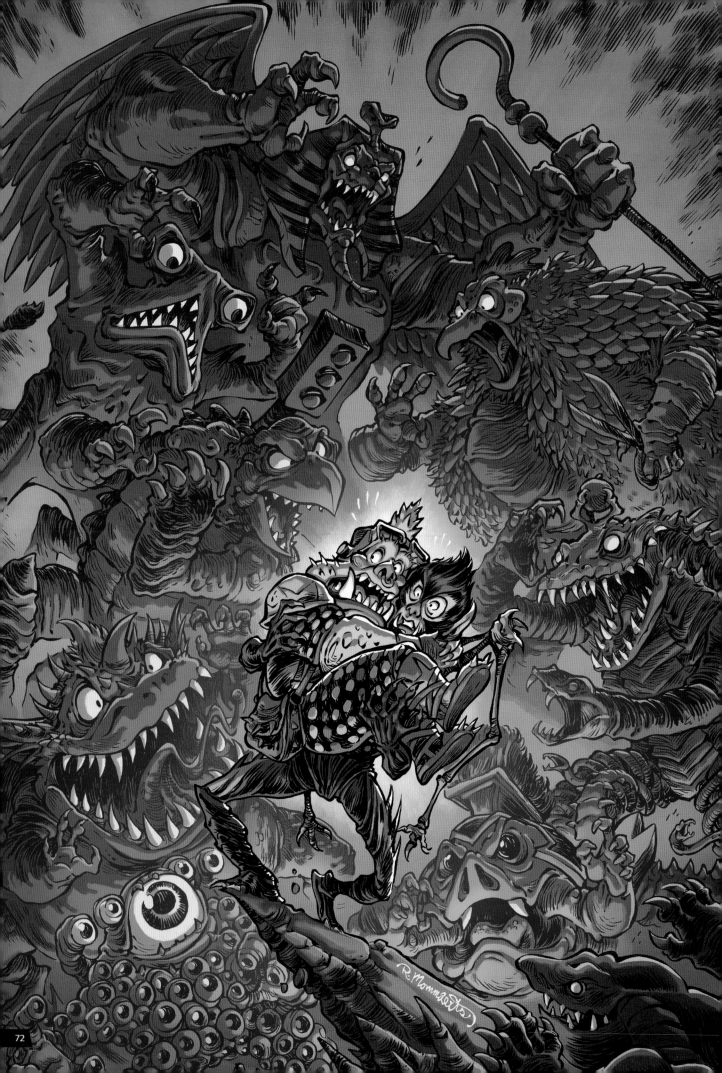

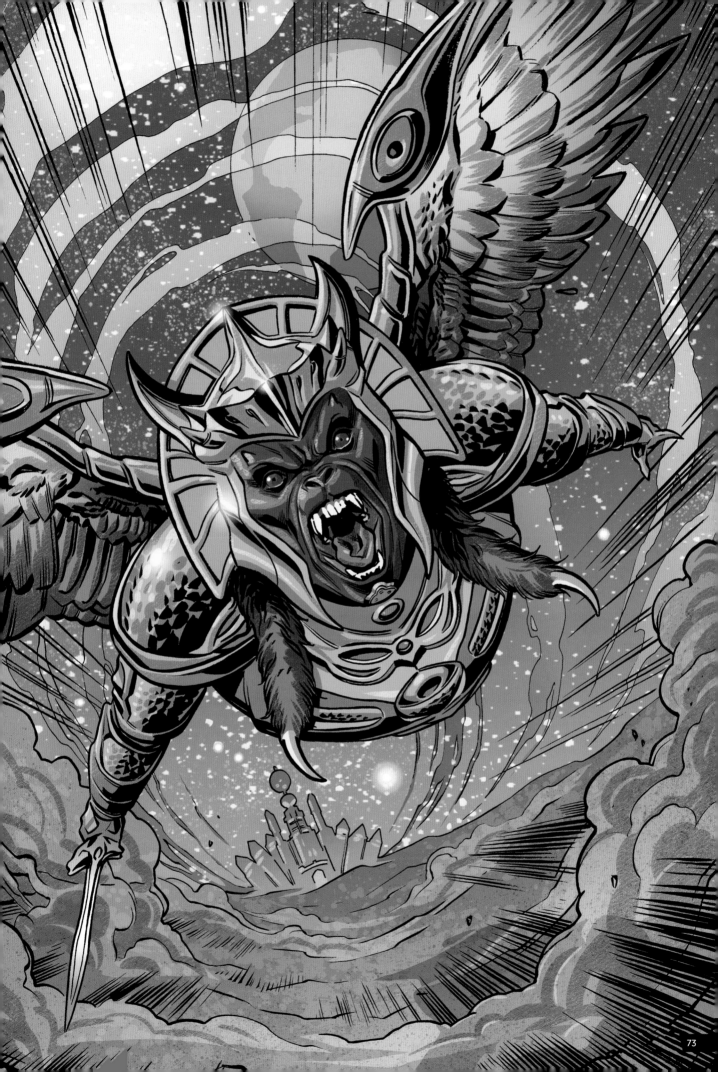

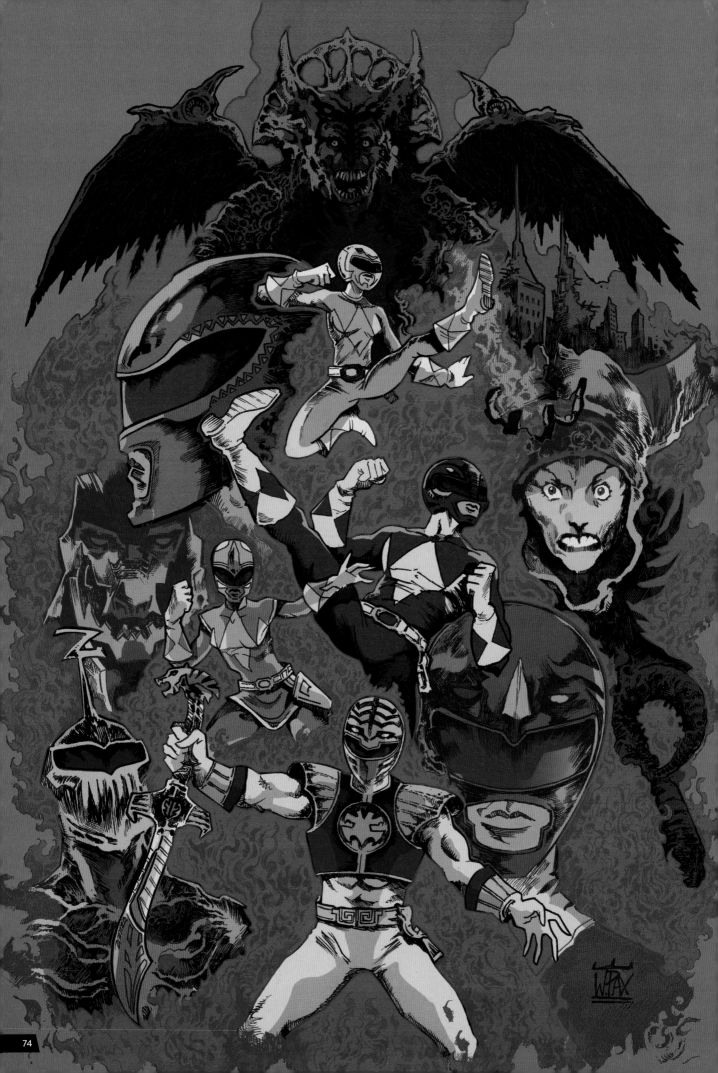

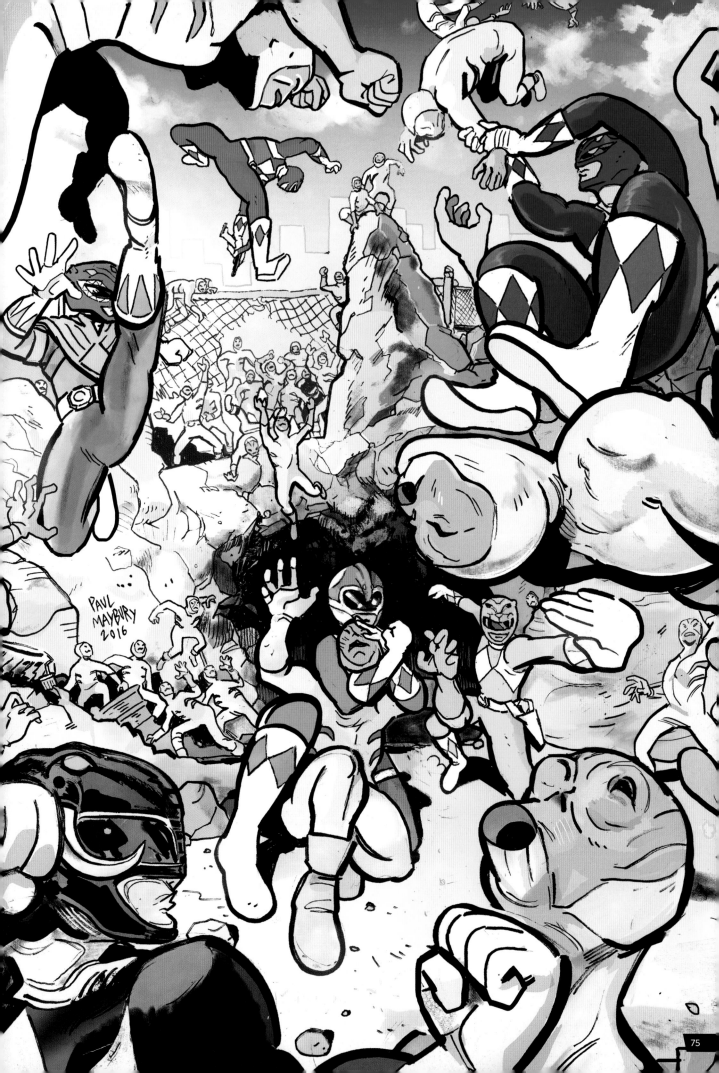

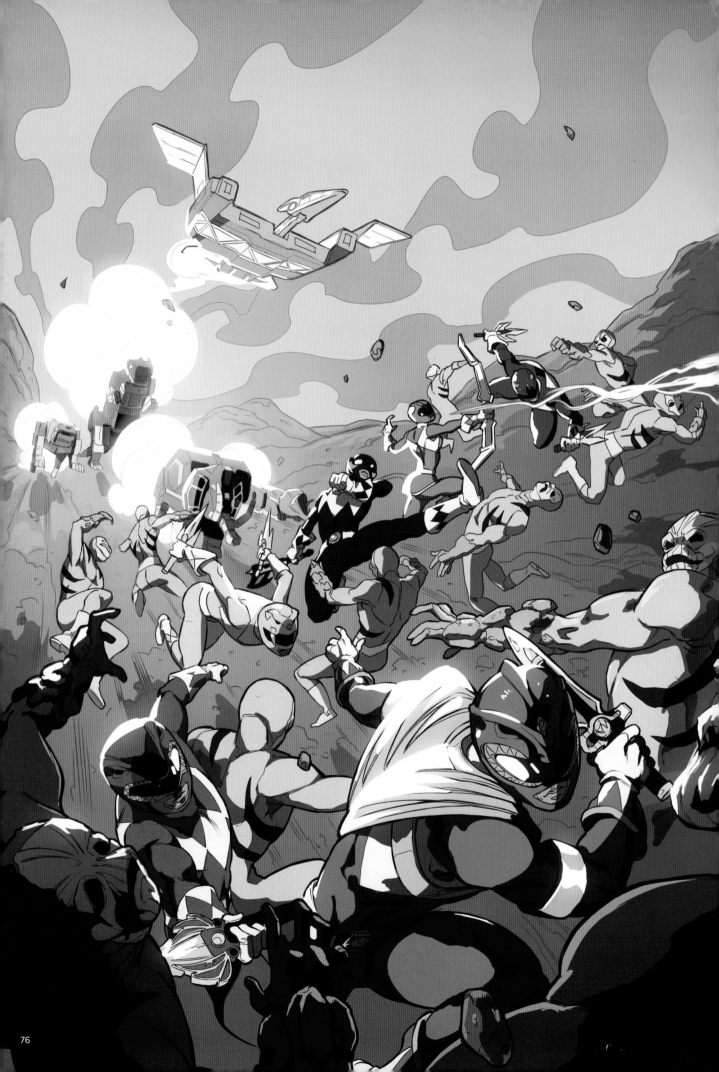

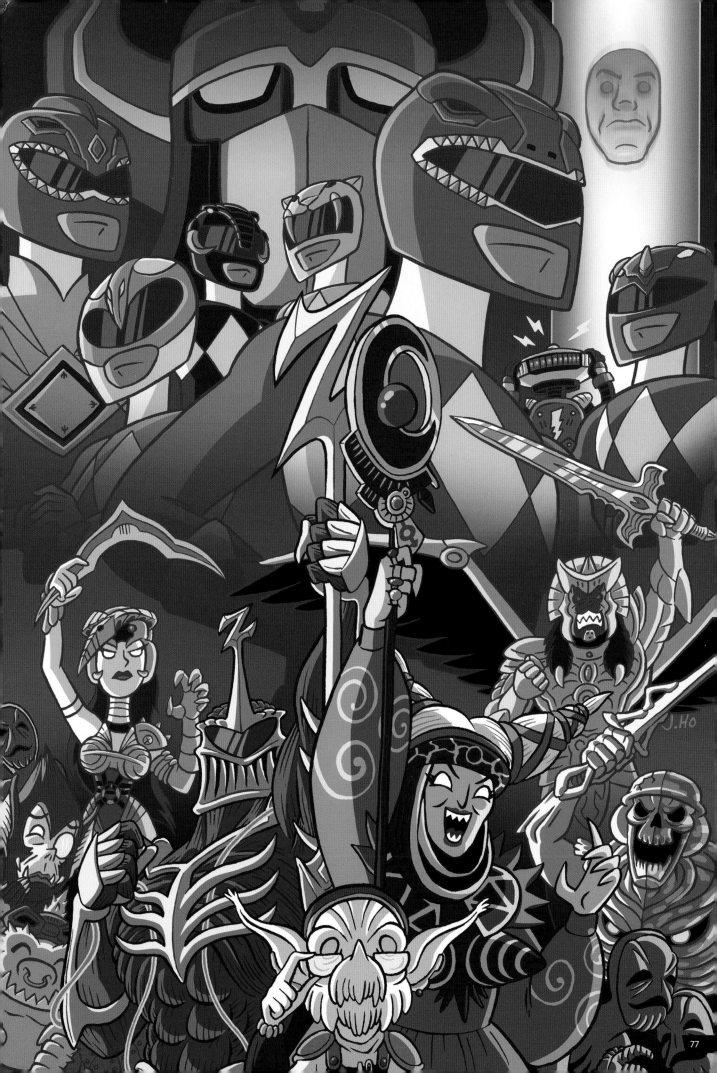

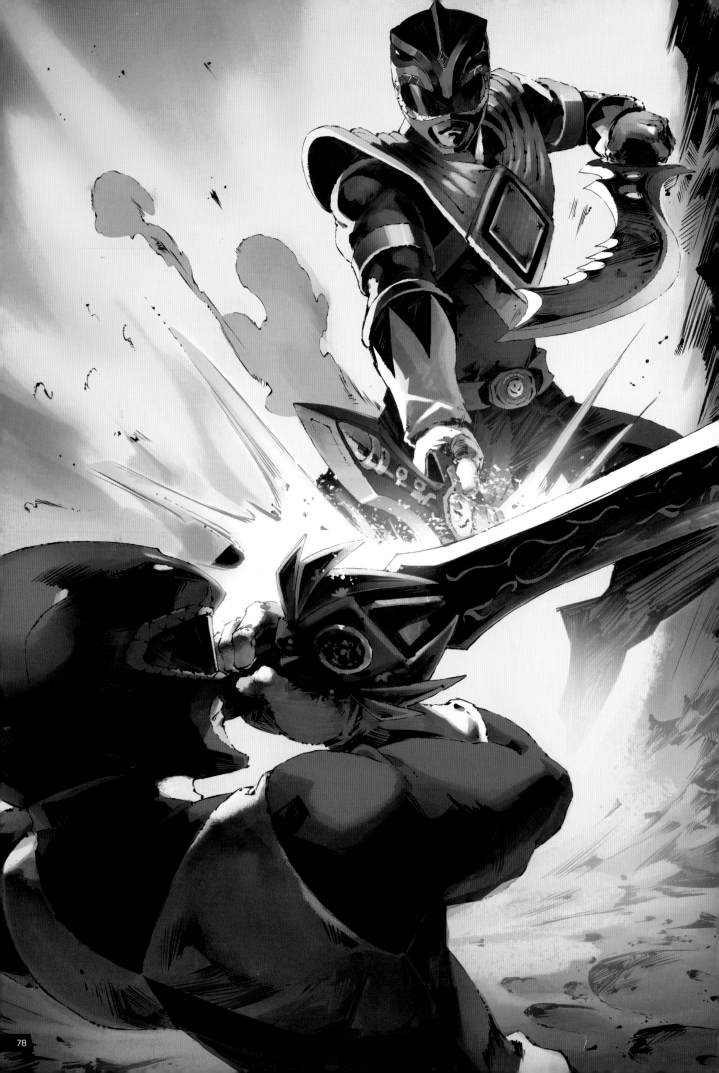

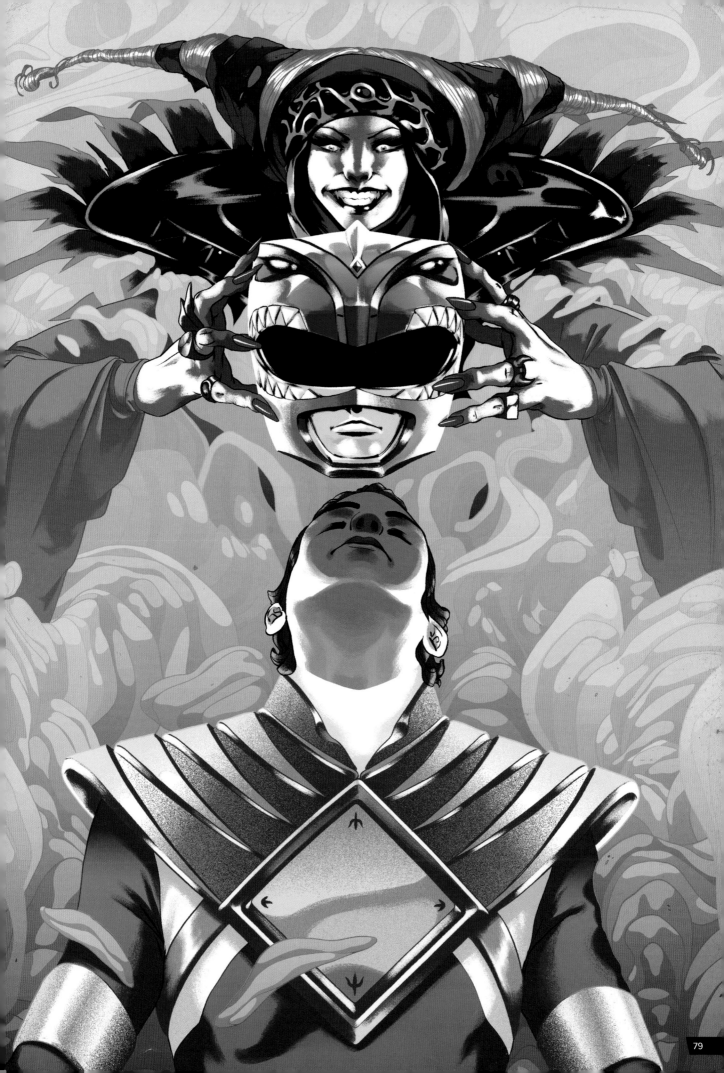

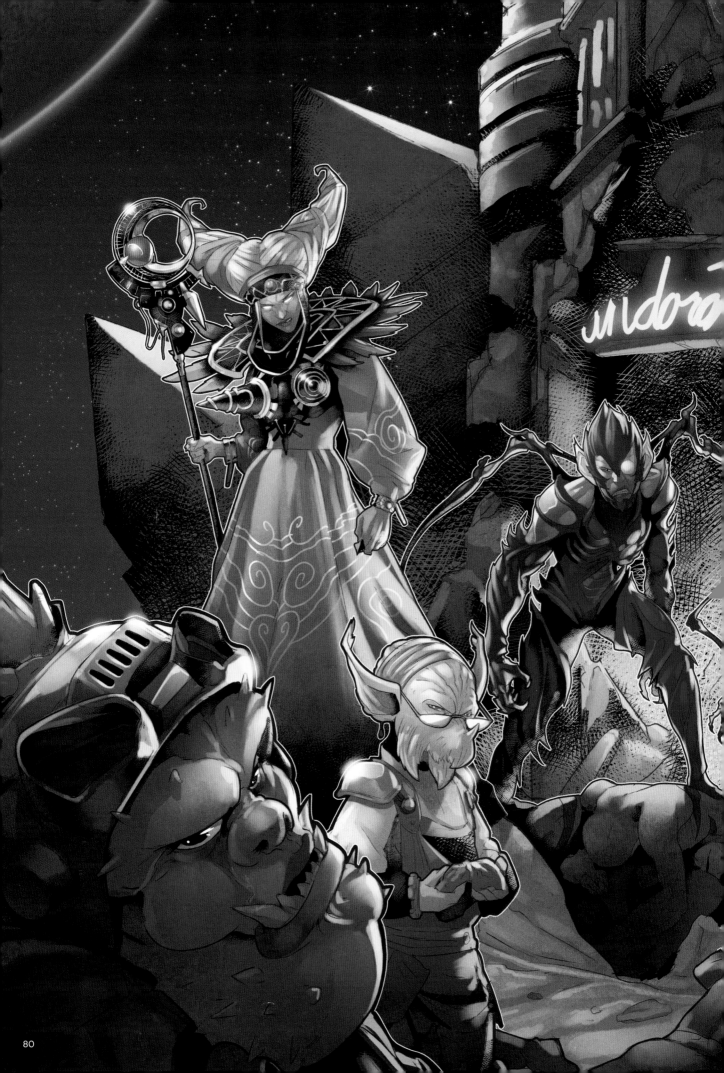

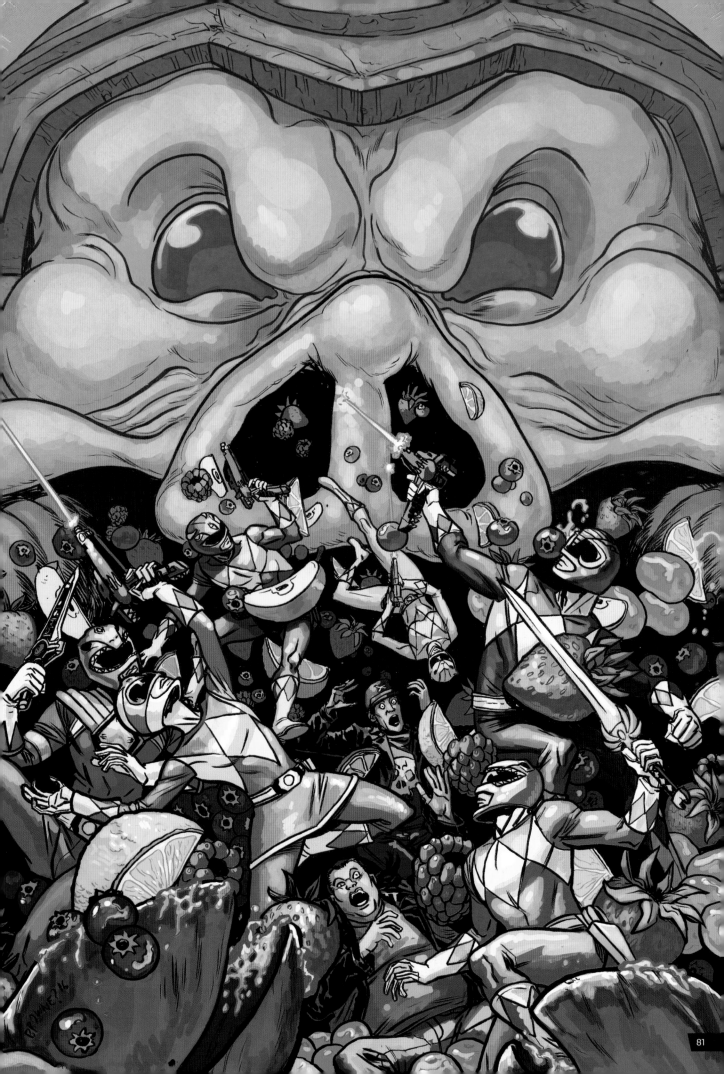

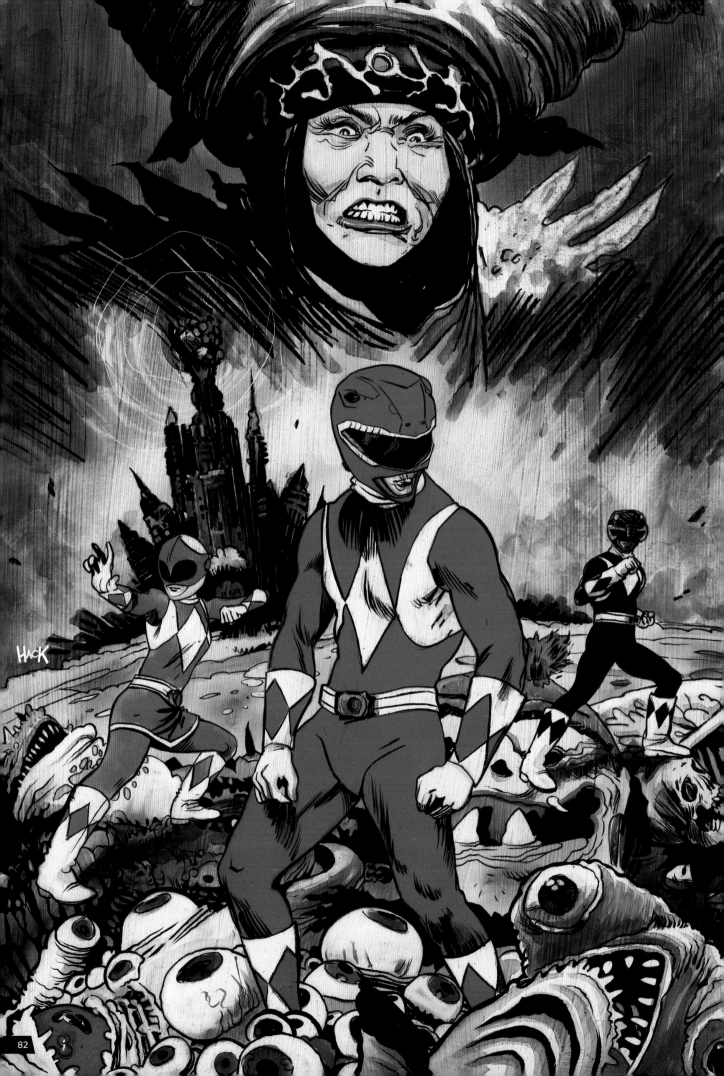

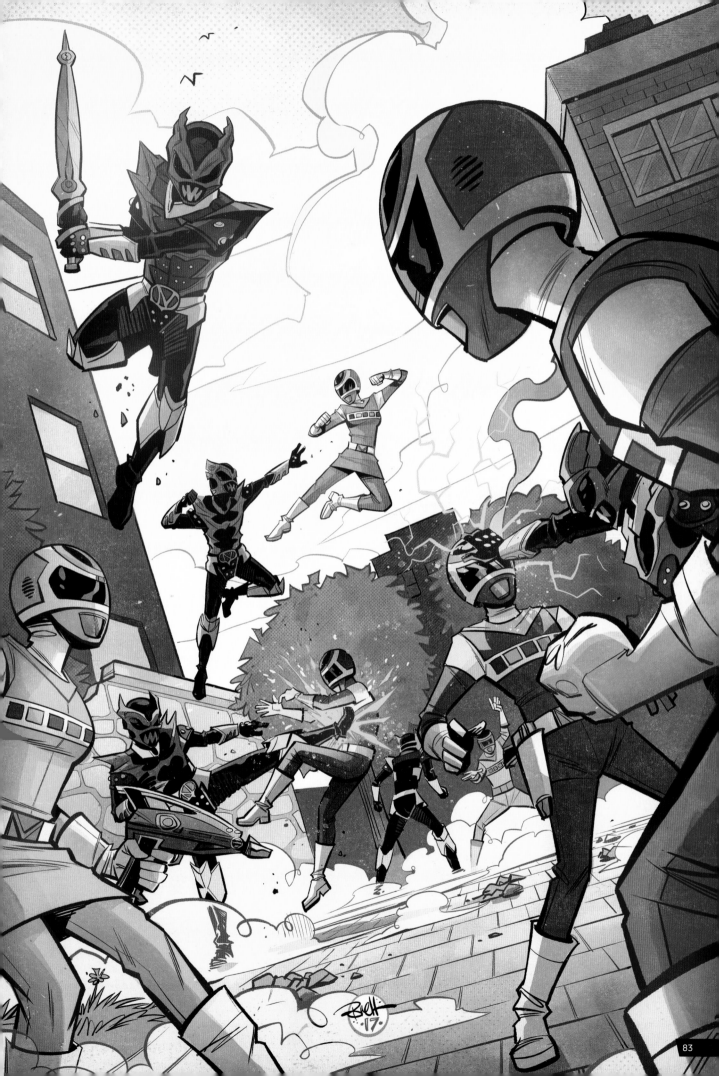

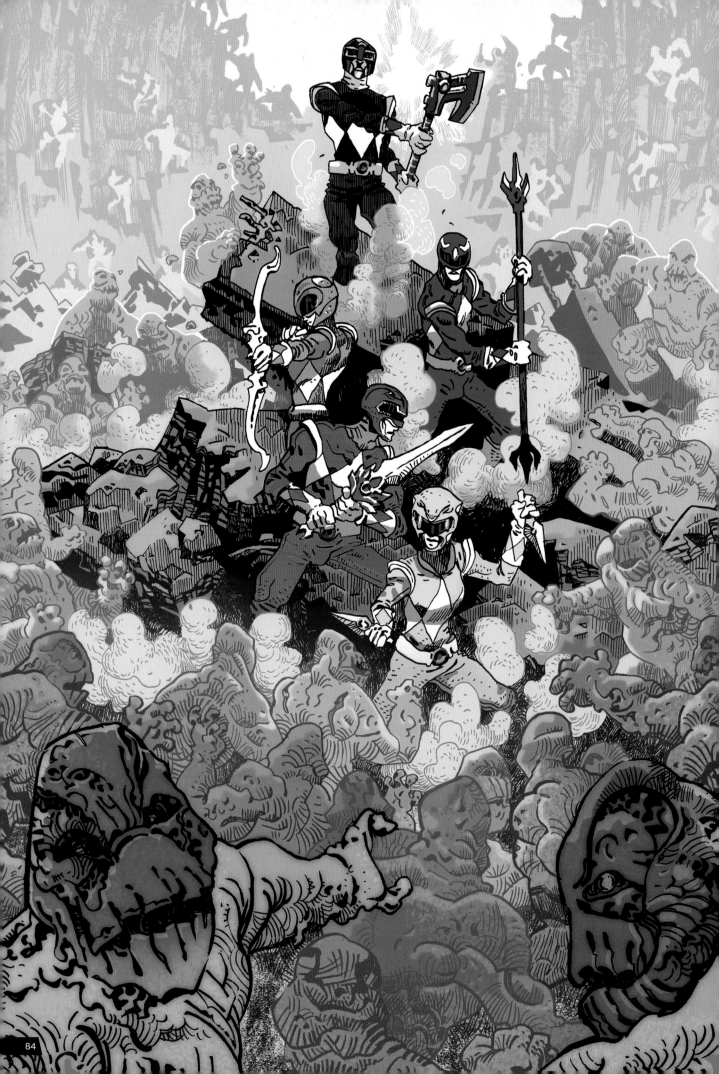

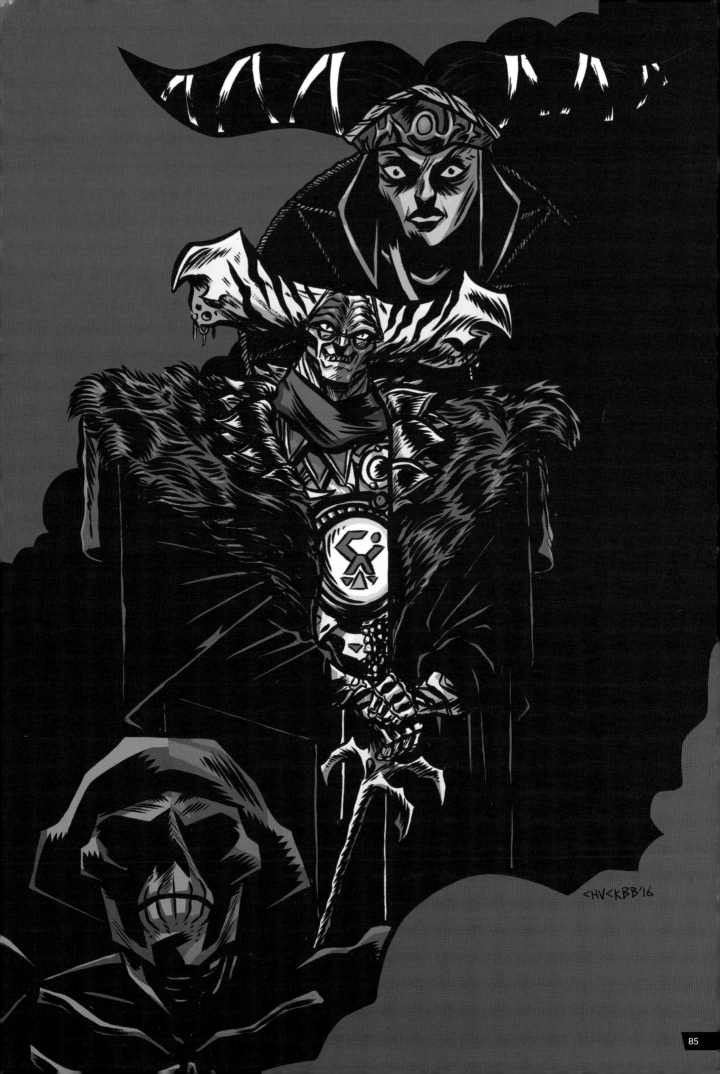

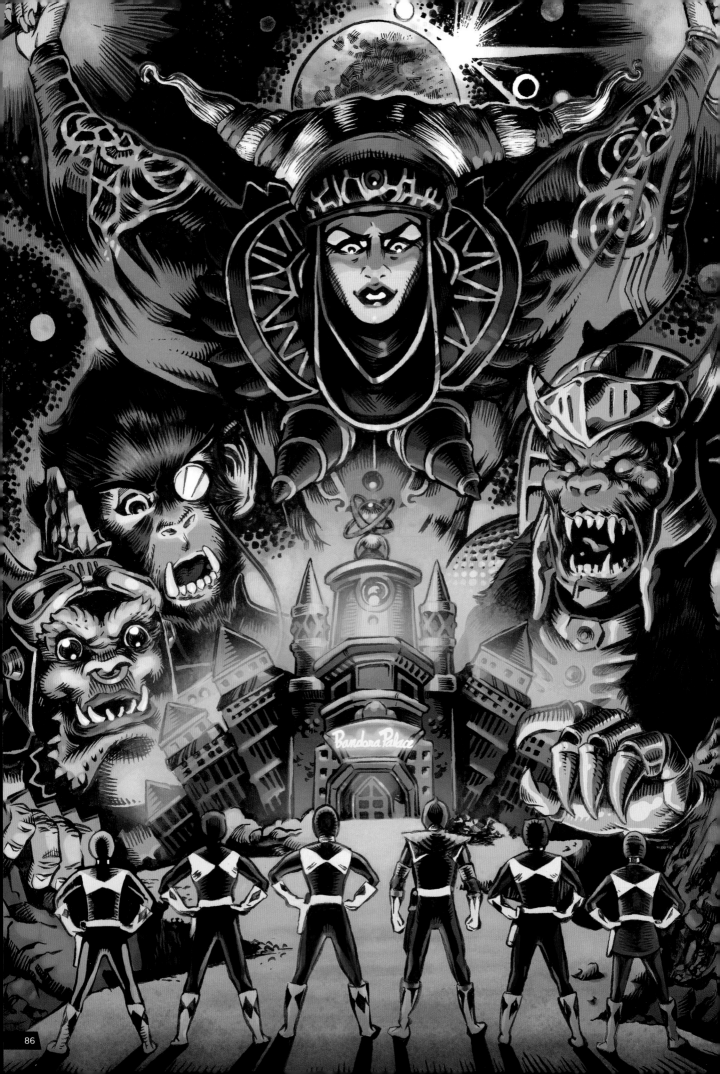

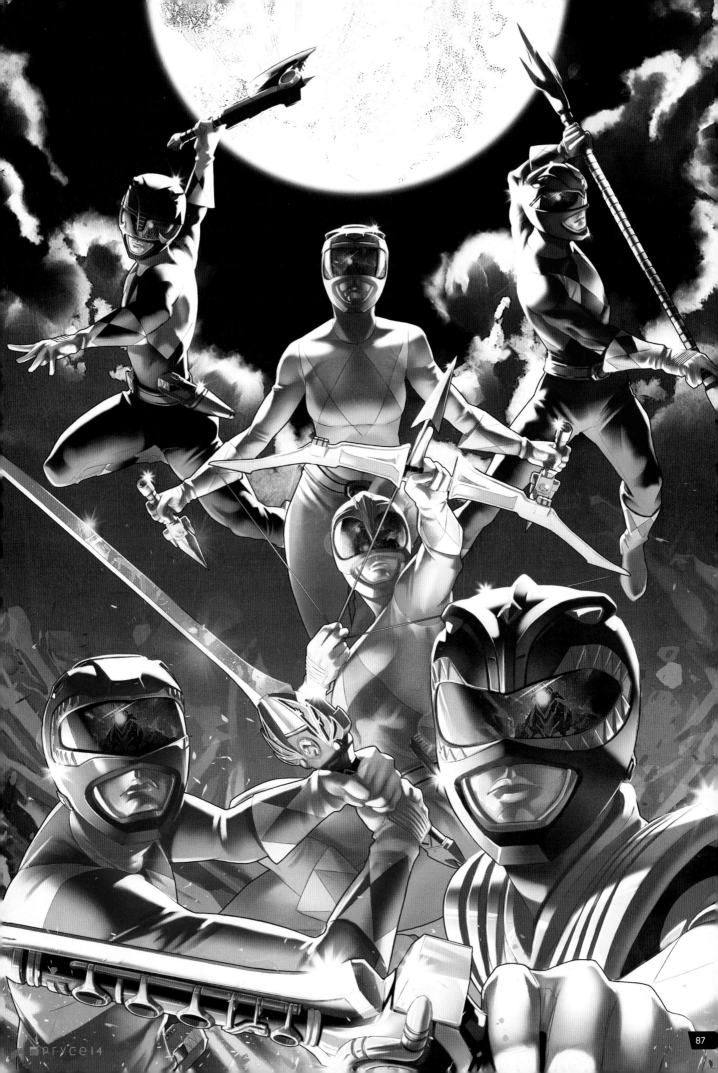

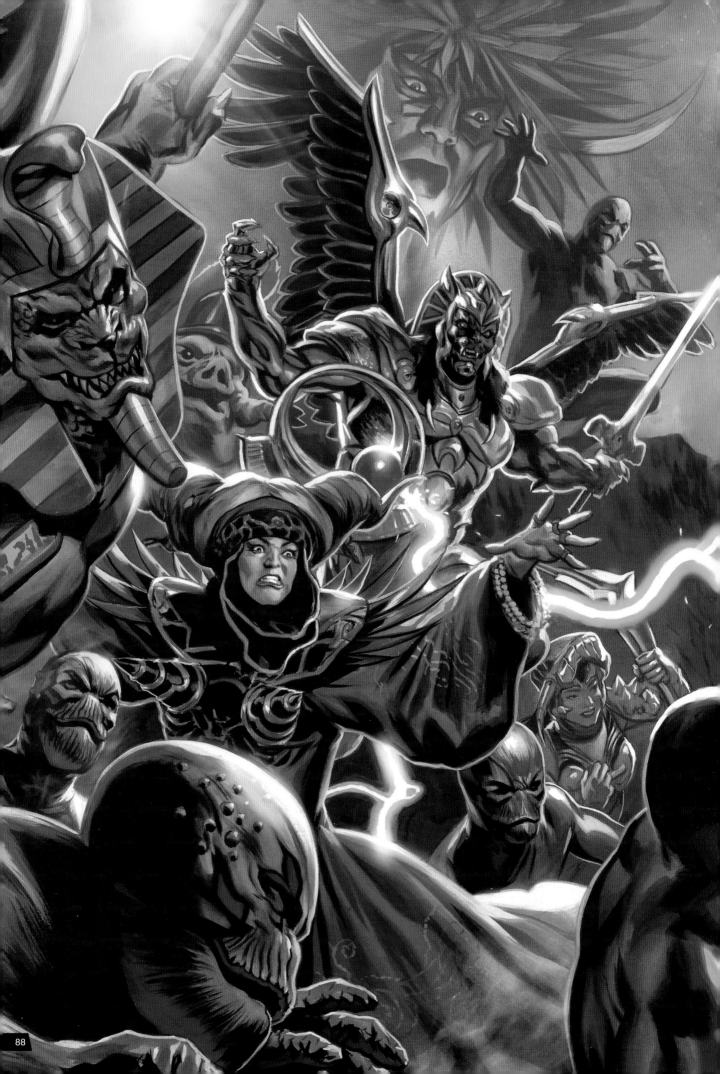

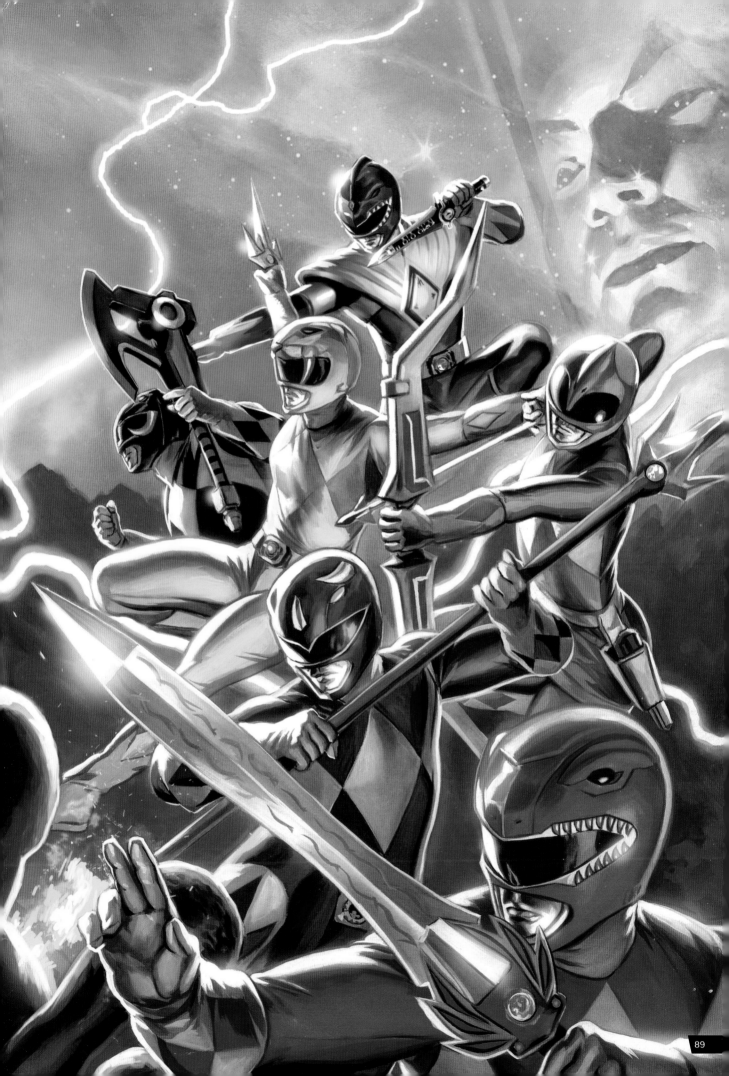

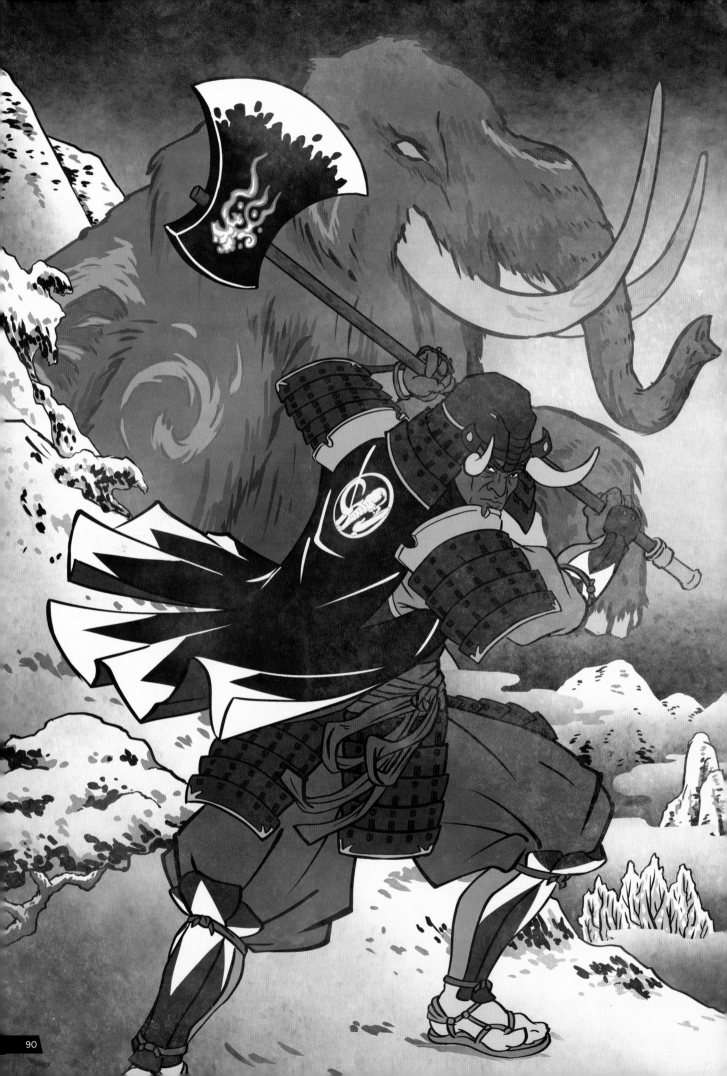

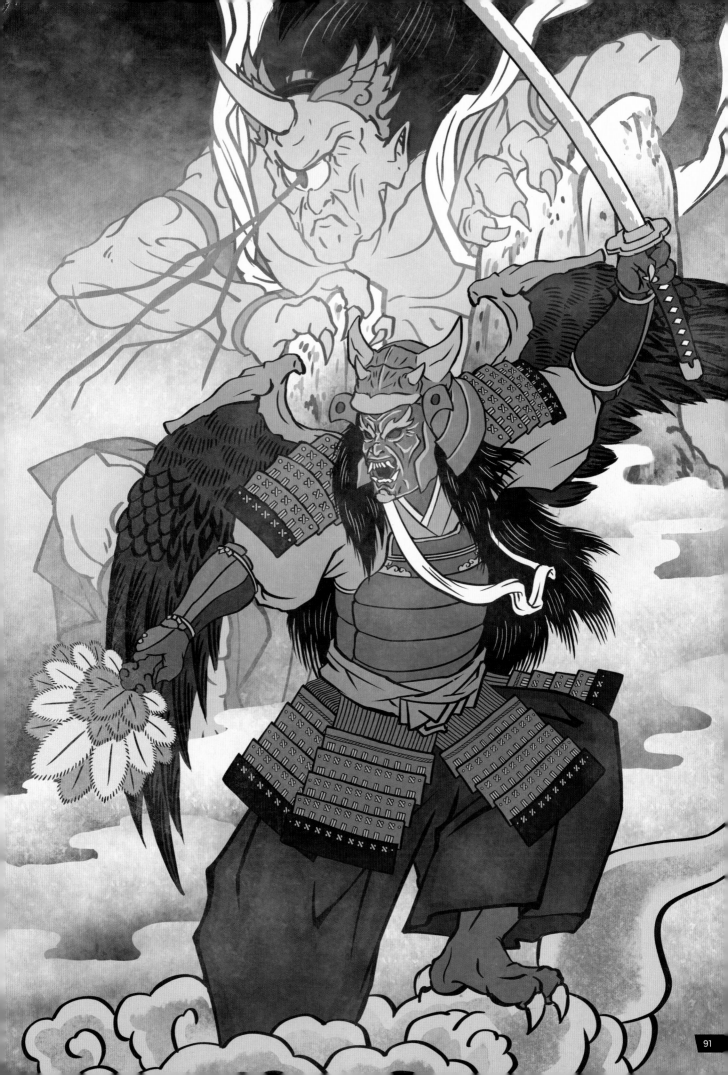

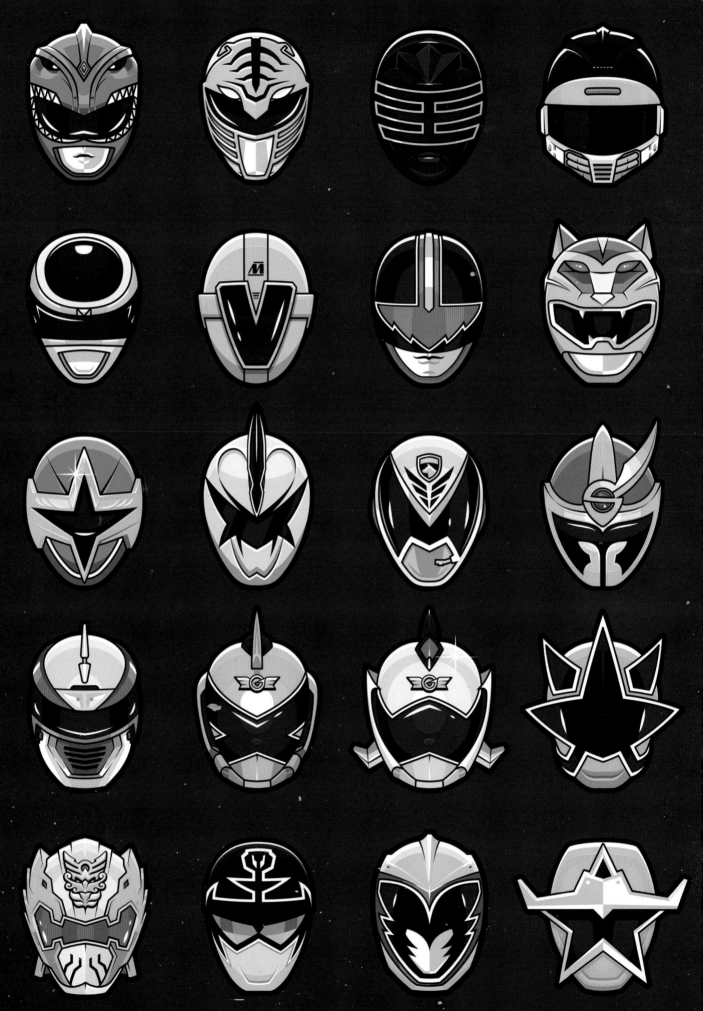

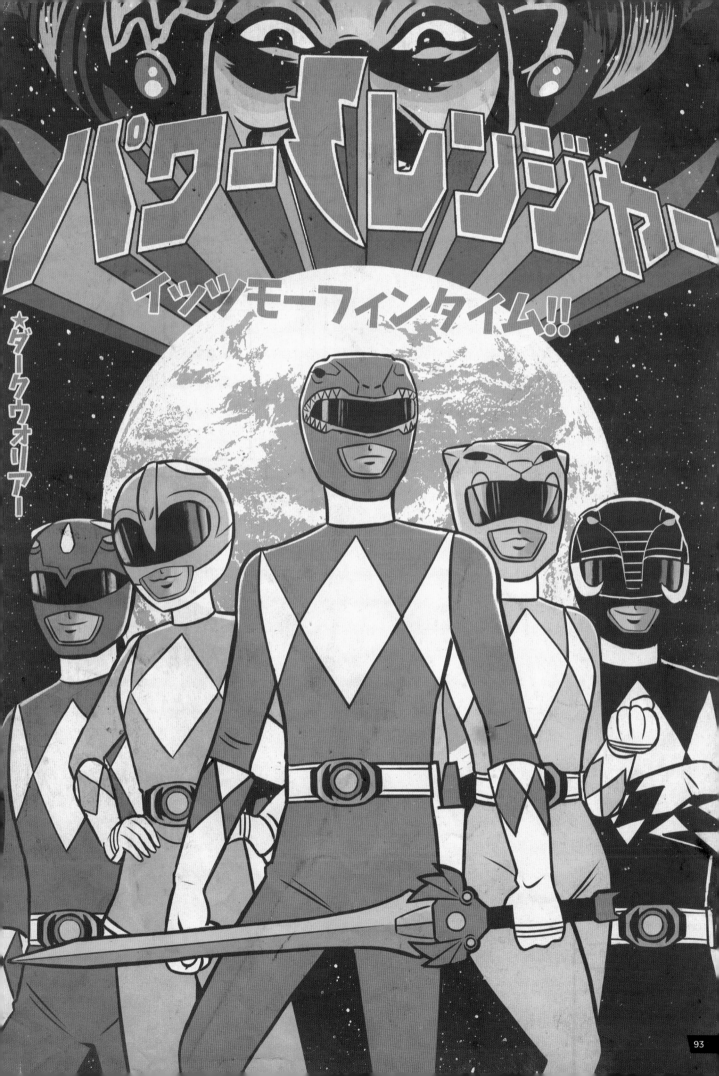

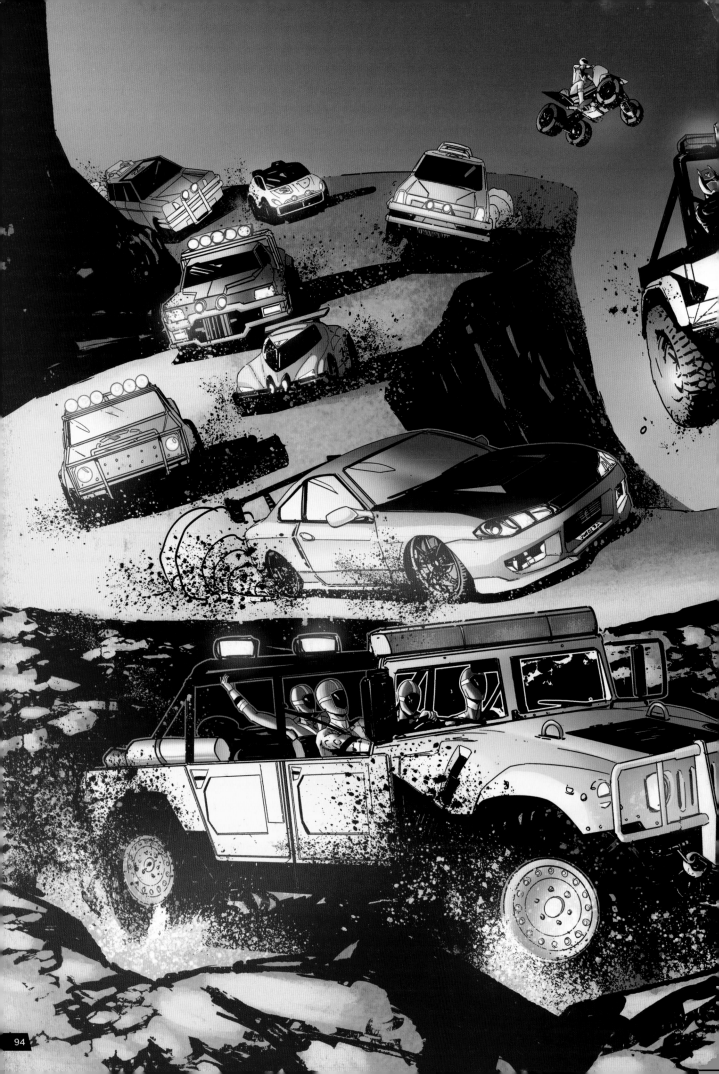

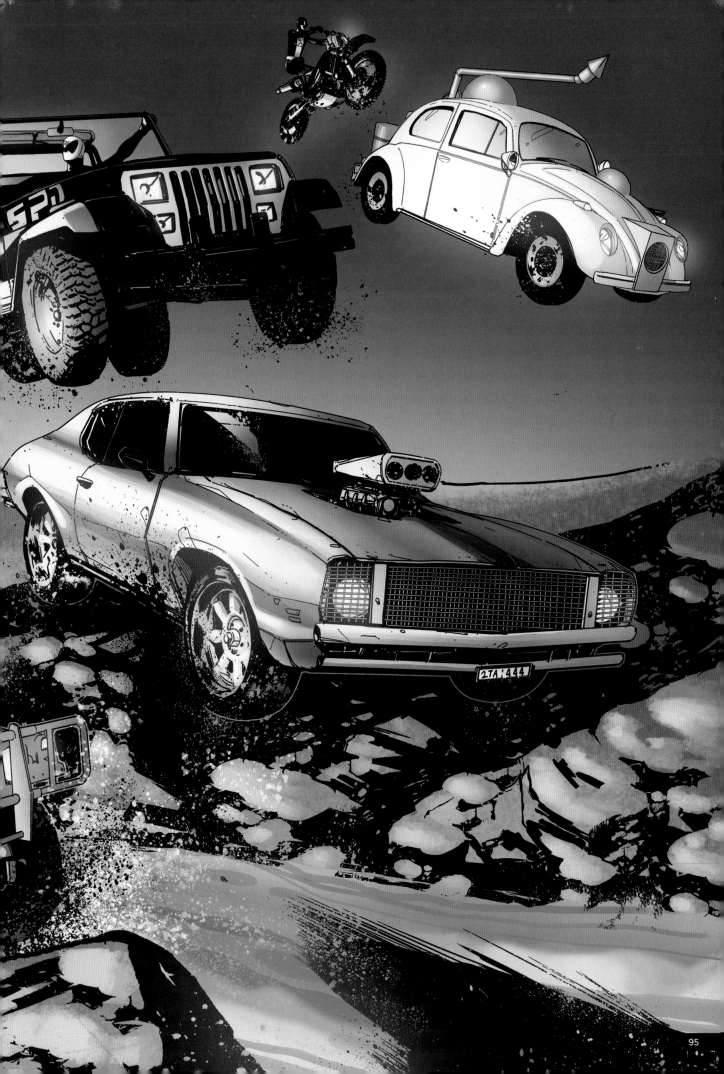

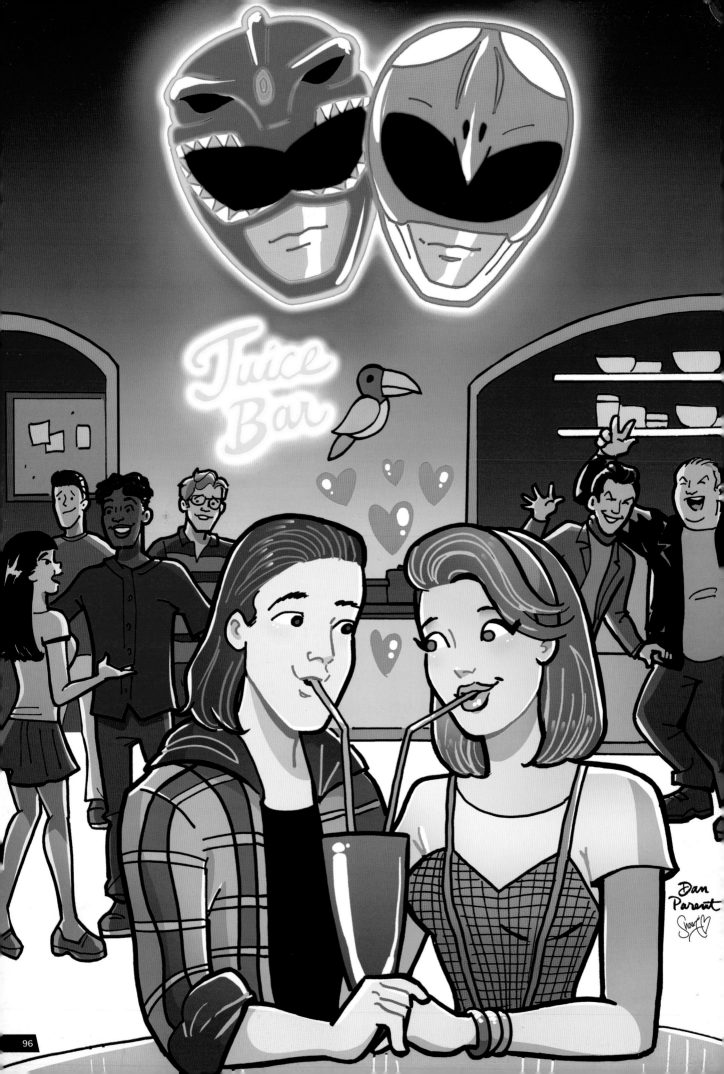

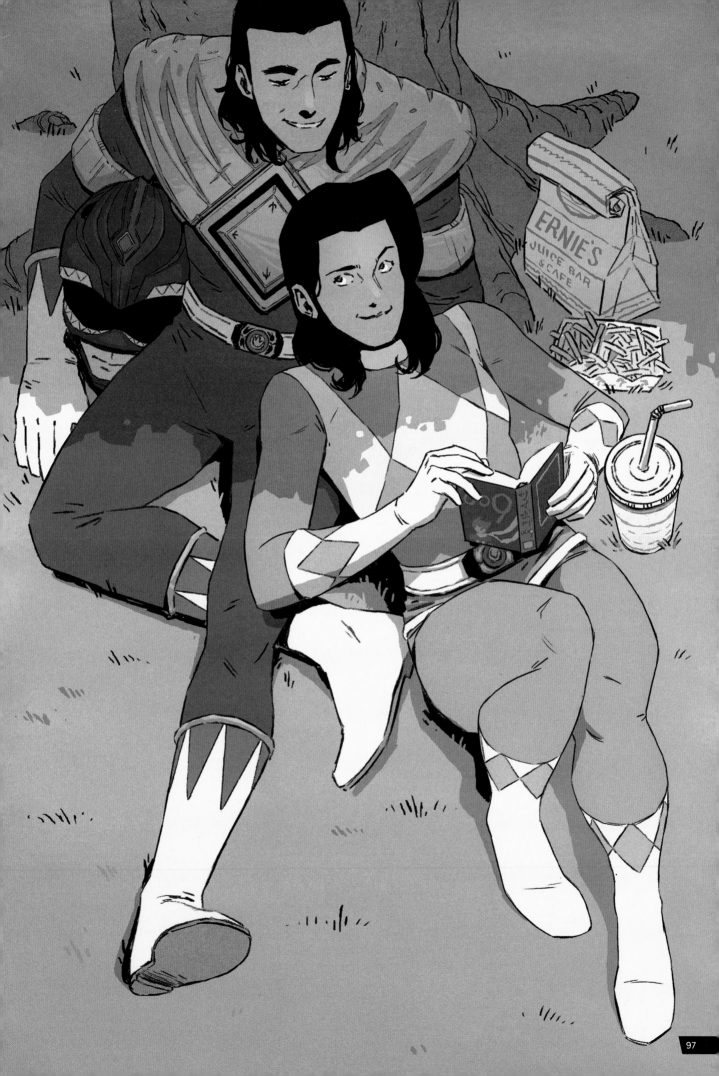

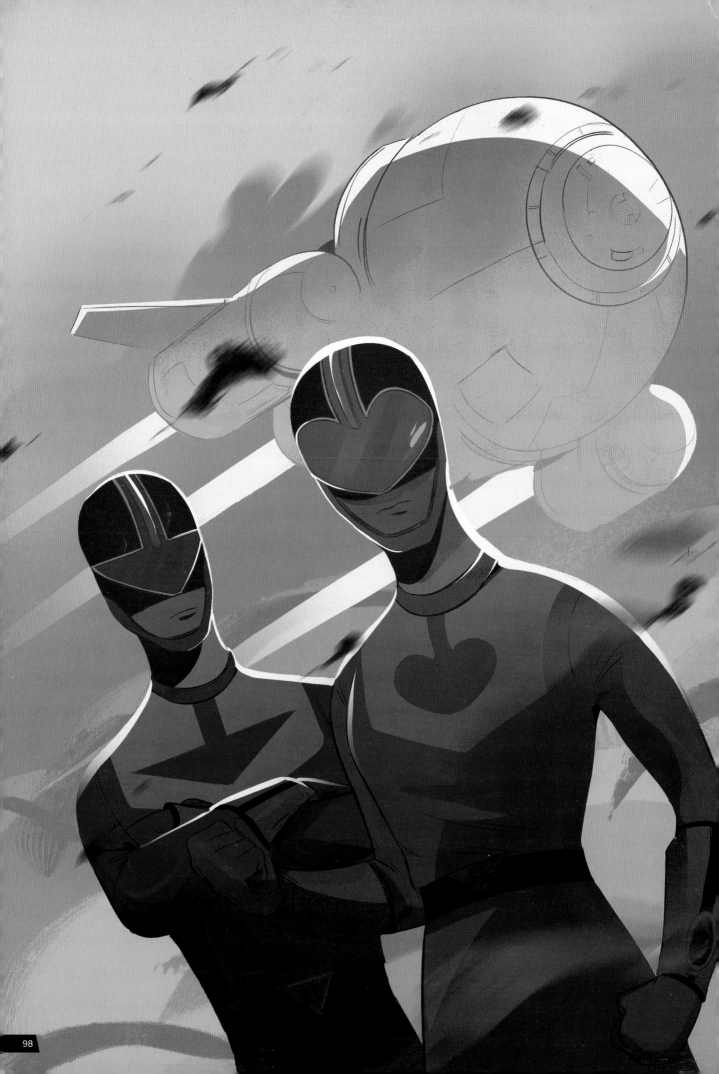

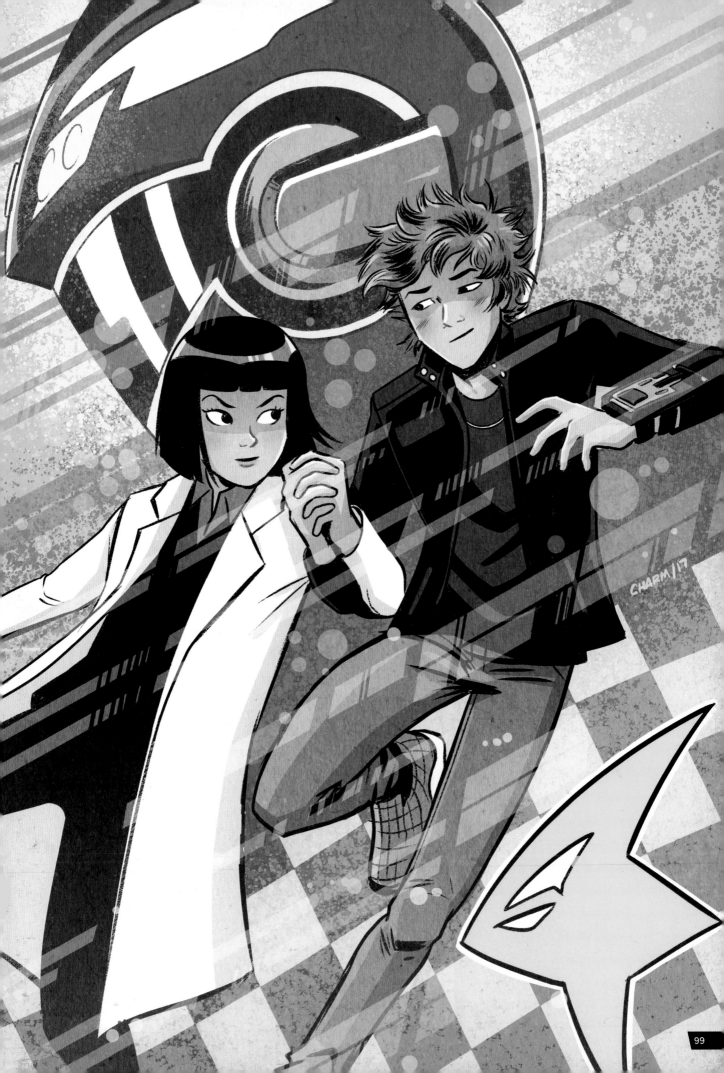

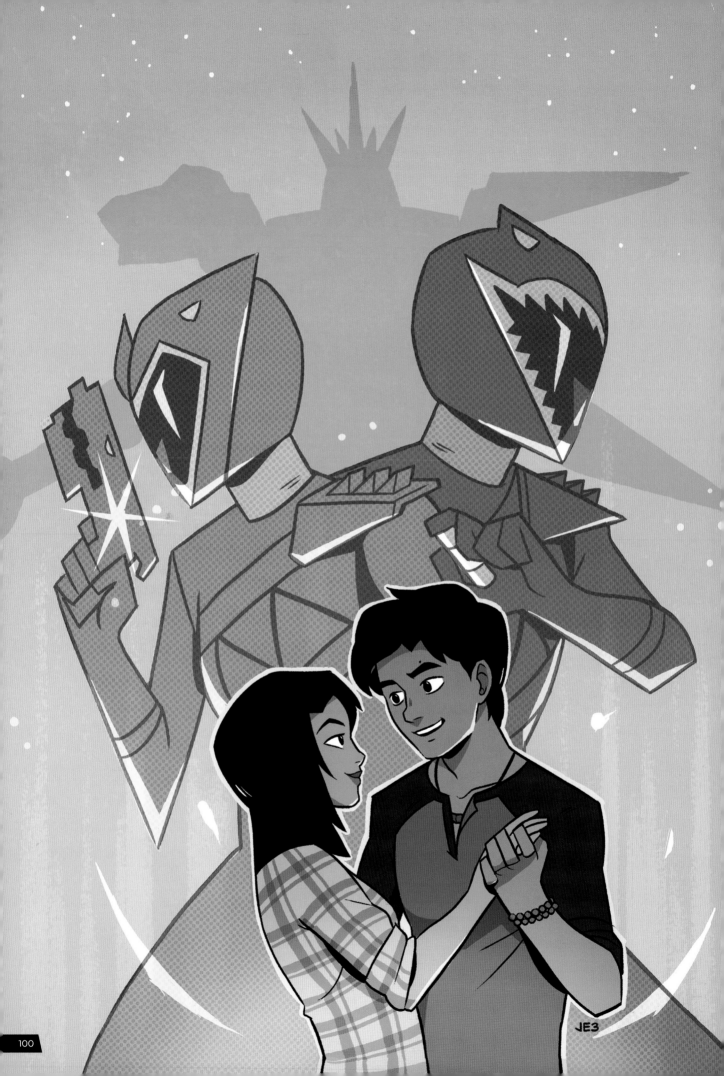

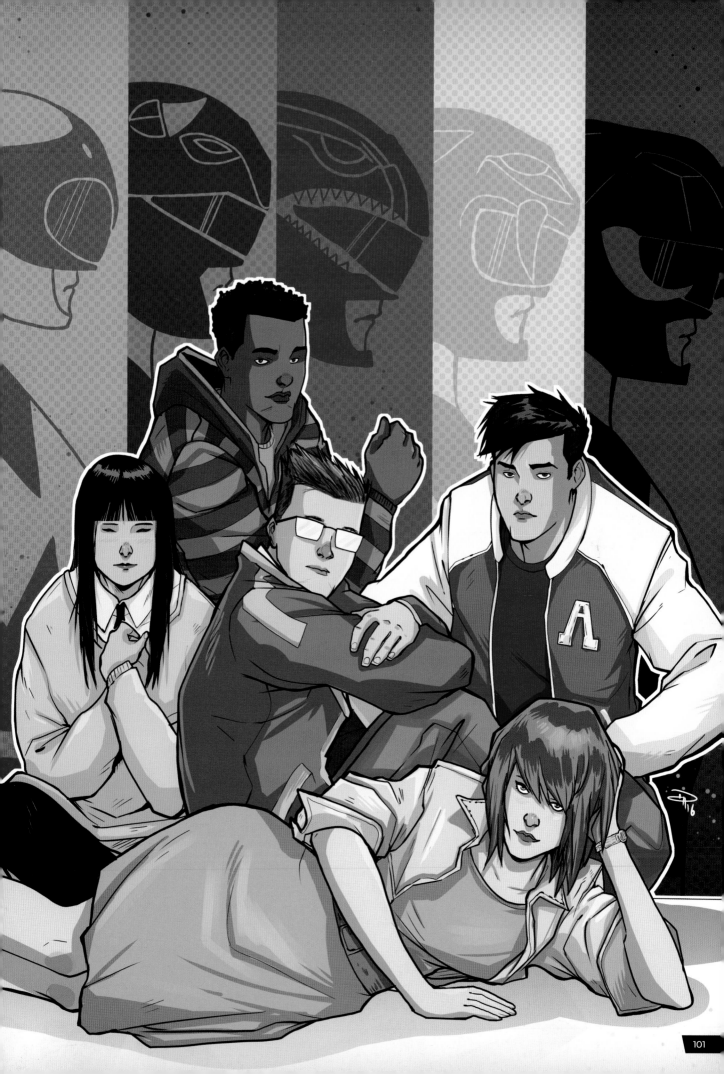

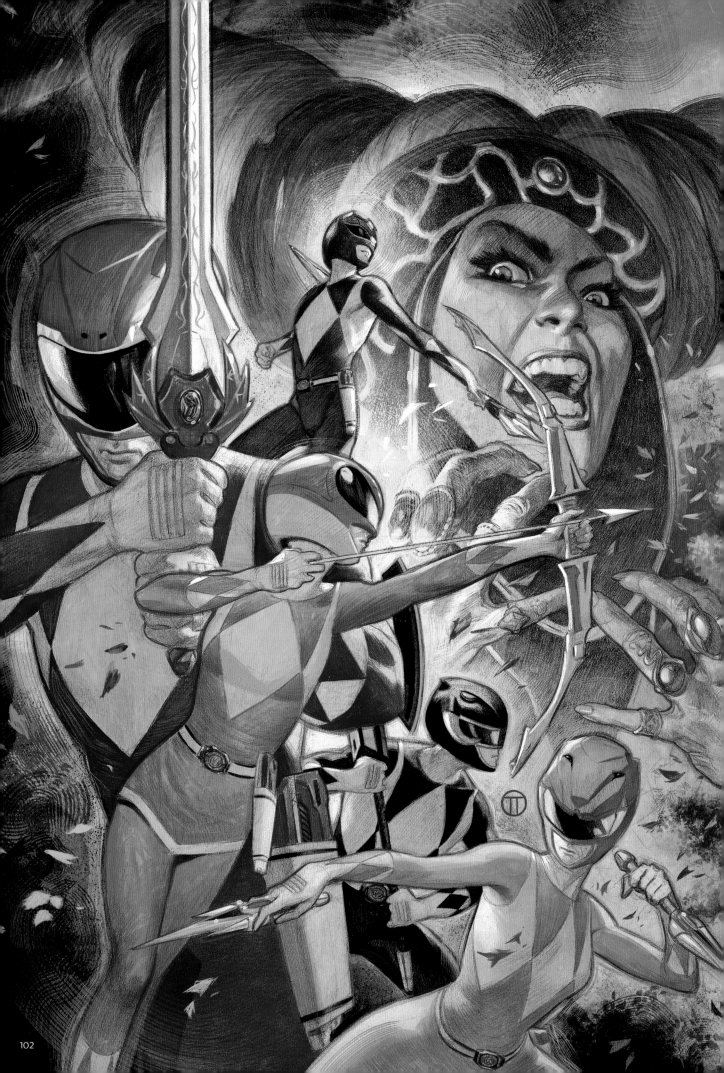

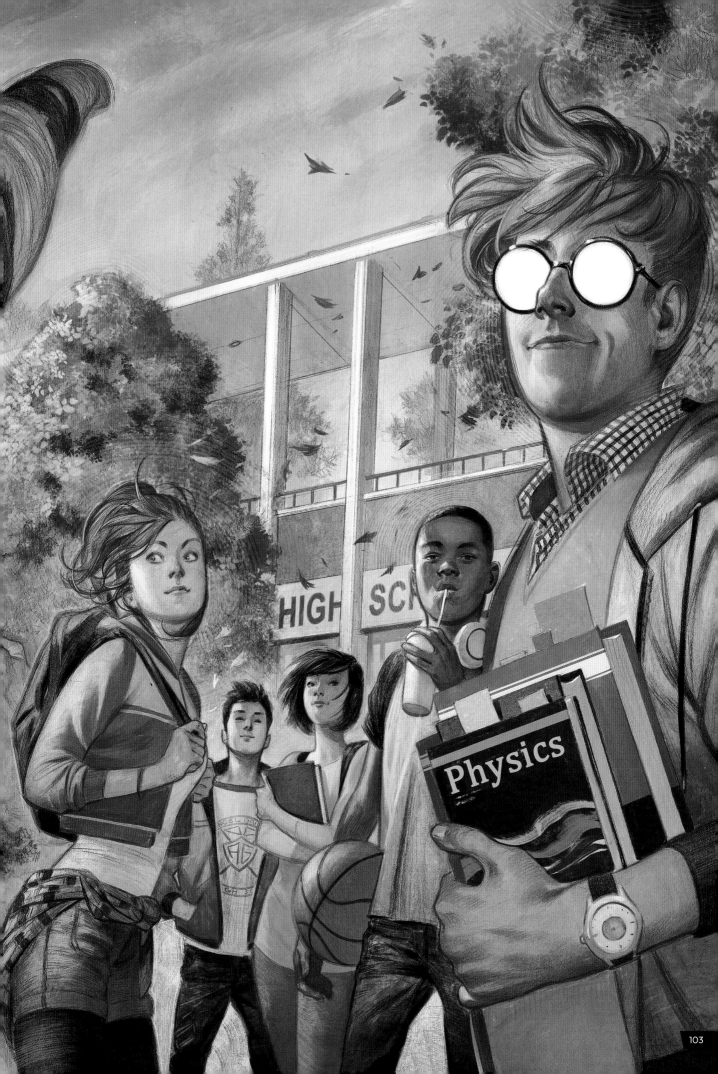

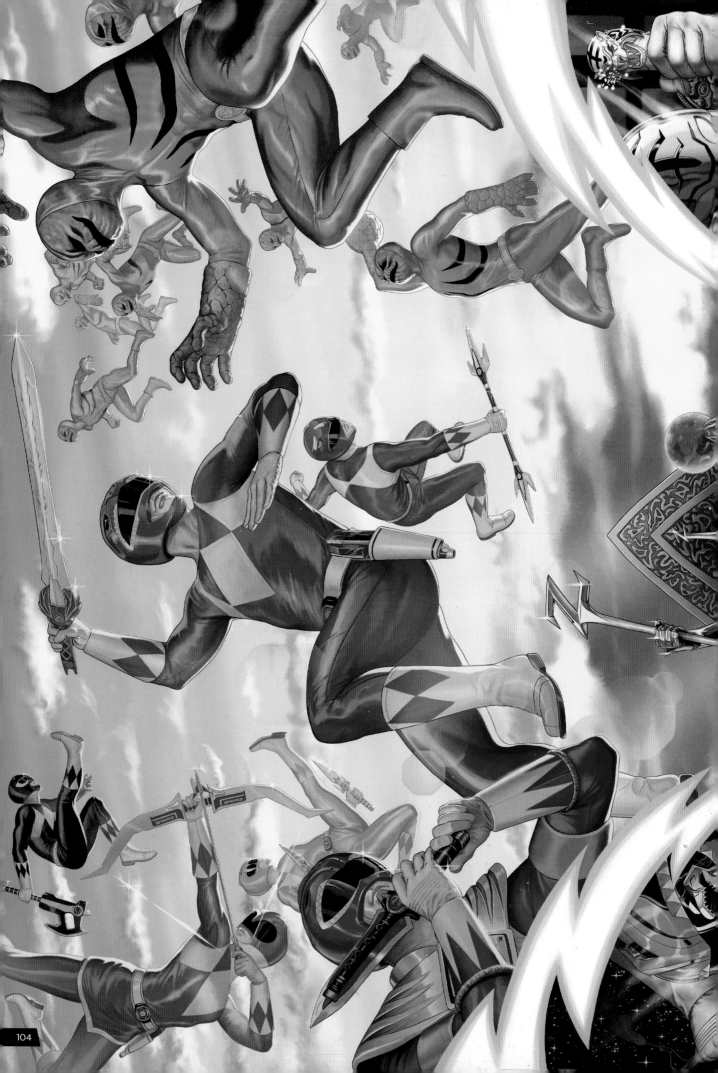

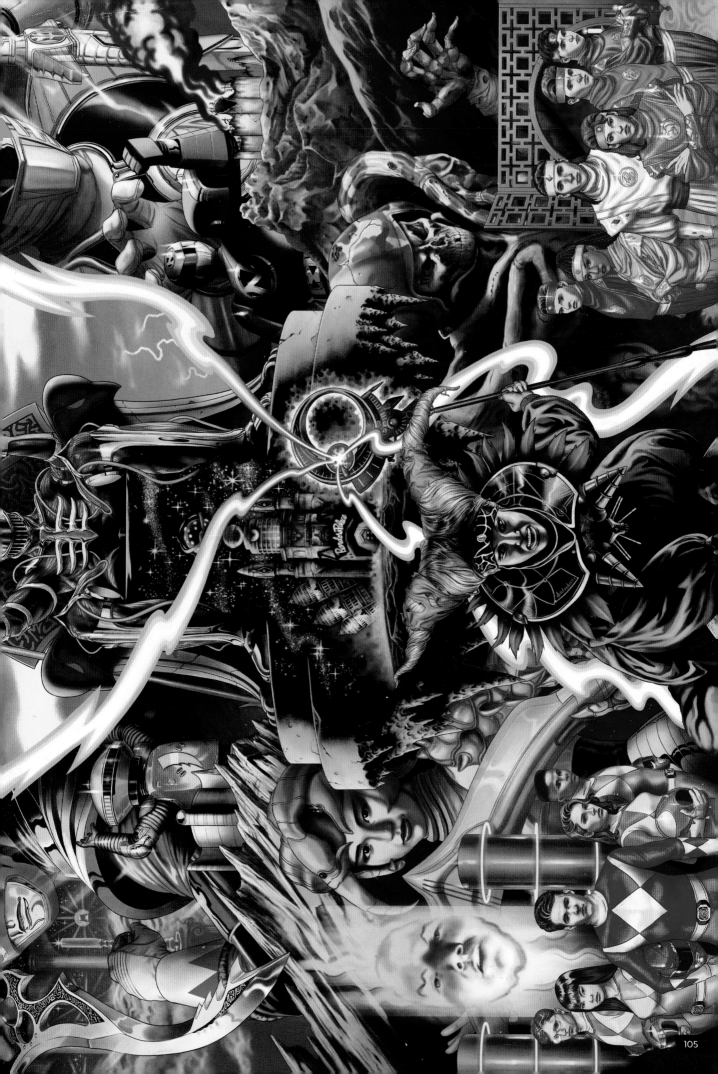

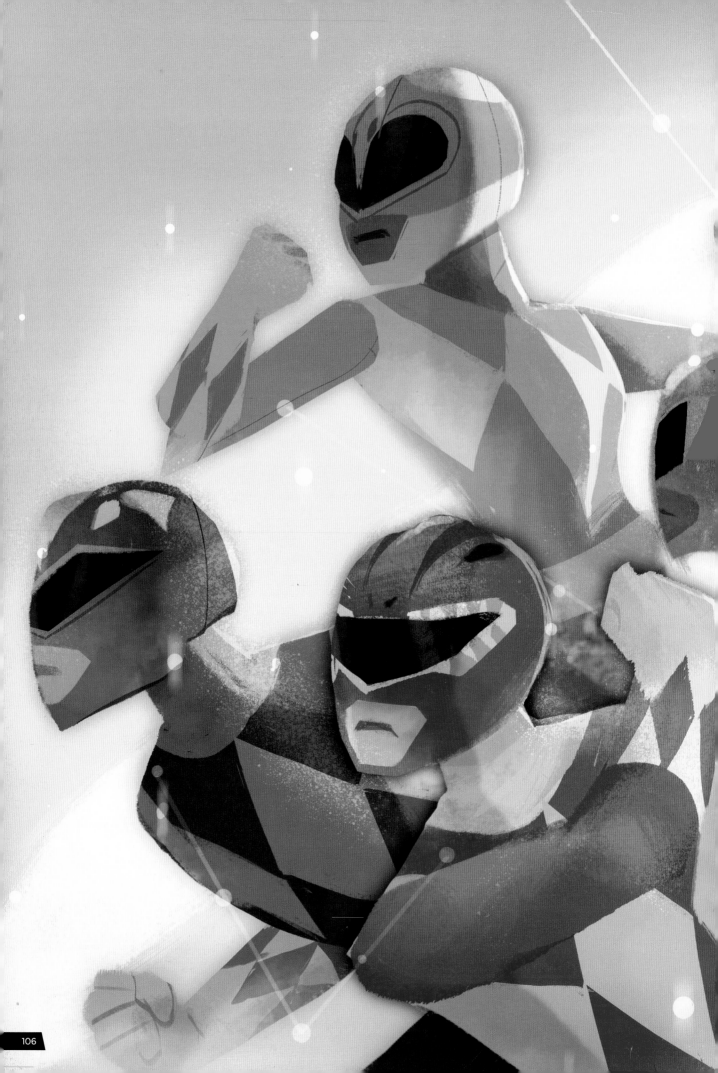

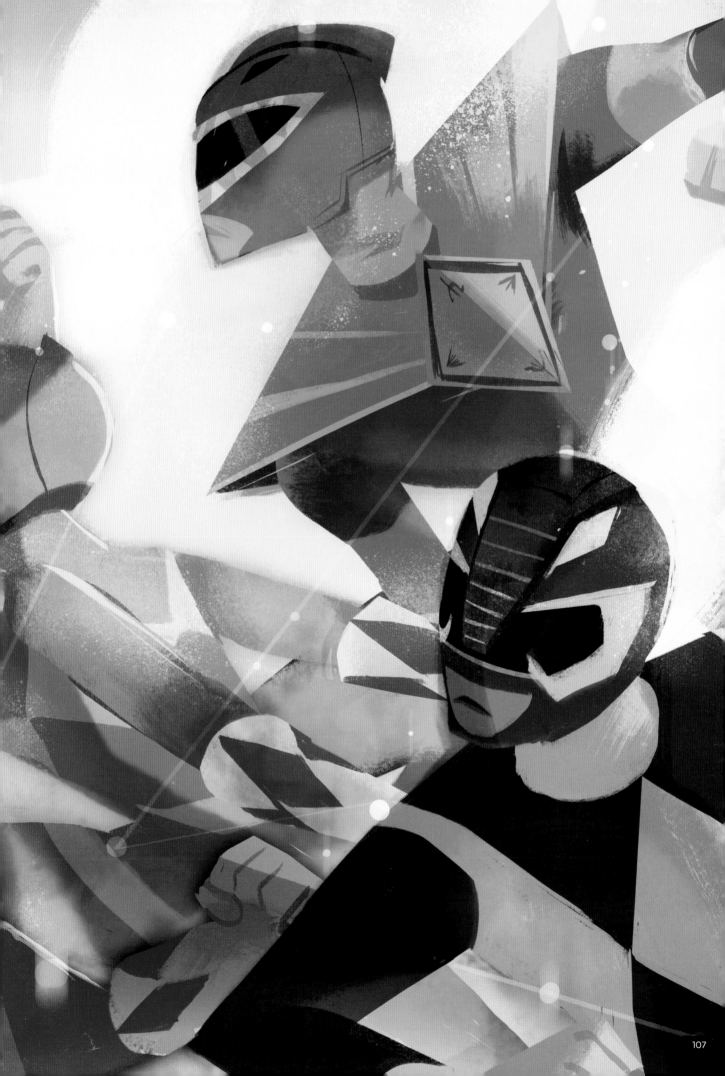

DESIGN BY JANICE CHU | No. OF EPISODE APPEARANCES: EIGHTEEN | HEIGHT: 44 METERS | WEIGHT: 150t

//003

WHITE TIGERZORD
P O W E R R A N G E R S

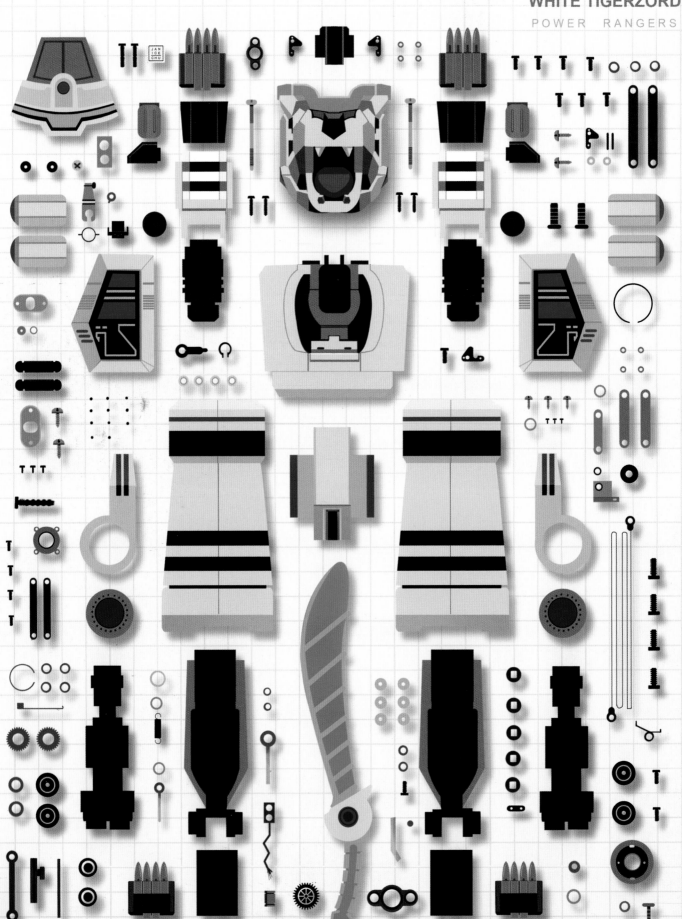

AFTERWORD

For more than a year, the dedicated, amazing staff at BOOM! Studios and the hardworking and passionate staff at Saban Brands have partnered together with brilliant writers like Kyle Higgins and Ryan Parrott and incredible artists like Hendry Prasetya and Dan Mora to release comic books that deepen and enrich the *Mighty Morphin Power Rangers* universe. The response has been overwhelming! Fans embraced the lore and the books that were more than just a dedication to nostalgia, but a true embrace of the series and a quest to further define these iconic characters with motivation, flaws, vision, and depth.

It's been a true pleasure and honor to be a part of that team, but I have a bit of a deep, dark secret that nowadays I find almost comical to admit: when I first came on board to Saban Brands, I didn't know very much about *Power Rangers*. That's not to say I didn't know of the franchise or I didn't like it, but as a preteen in the 90's, I was more focused on my extreme obsession with *Beverly Hills, 90210* and my undying love for Jason Priestley. *Mighty Morphin Power Rangers* was unique and interesting, but given that I was a preteen who believed myself way too cool to focus on anything but Jason Priestley's majestic eyebrows, it kind of passed me by.

So when I was hired by the fantastic executive producer Brian Casentini back in 2010, I entered into what I can only describe as a *Power Rangers* boot camp. Saban Brands had reacquired the brand from Disney only a few months before, and things were running at a mile a minute. Flung into the *Power Rangers* hemisphere, I needed to learn as much as I could about *Power Rangers* as quickly as possible. It was a deep dive. I needed to become familiar with every single Ranger that ever existed, every theme, every season, every episode, every weapon...etc. In the months that followed, I consumed myself with tracking down assets, trawling through warehouses, combing through literal treasure troves of props and spandex suits and shiny helmets that I needed to learn to identify. In my off hours I would pull old VHS tapes and screeners off shelves and immerse myself, binging over 700 (now over 800!) episodes to get through as much as I could.

The experience was remarkable. I thought I knew what the franchise was: superhero teens in brightly colored spandex fighting rubber monsters with enthusiastic 'hi-yahs!'. I quickly realized that viewpoint was entirely superficial. As I got to know the brand, I found myself increasingly impressed with the values represented: teamwork, diversity, equality, responsibility, fitness. It didn't matter what season of *Power Rangers* I watched, those values are always present. And yet, every theme was compelling and different in its own way. This is a kid's live action series, but it's also so much more.

At its core, *Power Rangers* is about relatable teens becoming superheroes with their friends, and the stories rich with incredible moments with incredible characters. My heart broke with Kimberly's as she

helplessly witnessed the Thunder Zords destroyed by Rito Revolto in Mighty Morphin Power Rangers. My chest tightened when Zordon sacrificed himself to save the world in *In Space*'s epic finale. Kendrix's death in *Lost Galaxy* left me gutted. I rooted for Jen and Wes to admit their feelings for each other in *Time Force*, and I cheered for the B-Squad Rangers in *S.P.D* when they triumphed over the traitorous A-Squad.

Basically, I fell in love with the franchise, and I became incredibly proud to work on something so unique and powerful that not only touched me, but fans of different generations all over the world. The fandom for *Power Rangers* is impressive and fierce. To say these groups of people care about *Power Rangers* is a severe understatement. I consistently find myself in awe and humbled by their dedication and passion. Their love stretches beyond any single season, though they very much have their favorites. And though I'm a graduate of my own version of *Power Rangers* Boot Camp, I would still never dare to enter a trivia test against them. They would beat me every time!

For 25 years, these fans have followed *Power Rangers* in its many incarnations, and it's for the fans that this book has been made.

The idea was a simple one: an artist tribute that spans all 25 years of *Power Rangers*, in celebration of our silver anniversary. The execution was perhaps a little less simple. 25 years of *Power Rangers* doesn't just mean the famous *Power Rangers*. Fans expect more than that. There are themes, and in every season: mentors, allies, villains, Zords and Megazords. How do we honor and represent these different elements in one book? Lists were made, sent back and forth with scribbles and notes. Elements were discussed and re-discussed. Just like with our Rangers, teamwork is an essential part of the BOOM! Studios and Saban Brands partnership and everyone had an opinion.

This book has been lovingly curated to include an amazing team of artists and represents the franchise at every level. It represents the vibrant facets of what makes *Power Rangers* so unique and special. Each season vibrates with gorgeous flair, from Rangers to mentors to romance and rivalries. The story of *Power Rangers* explodes from the ink and colors with beautiful diversity and style.

I sincerely hope you enjoy the book as much as I enjoyed being just a tiny part of the process that went into making it. It's an incredible love letter to the fans by a team of fans.

Go Go Power Rangers!

Melissa Flores
Director, *Power Rangers* Content
October 2017

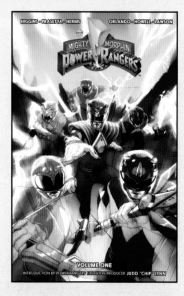
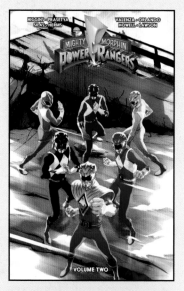
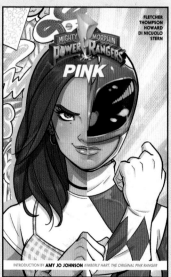
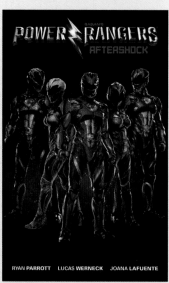